TANGLED TREASURES

coloring book

52 INTRICATE TANGLE DRAWINGS TO COLOR WITH PENS, MARKERS, OR PENCILS

Creative Publishing
international

CONTENTS

INTRODUCTION

Welcome to my first coloring book. I believe color and coloring are wonderful gifts to your inner child; a return to a time when you had freedom to choose color without rules or adult reasoning. Coloring is a relaxing and simple way to de-stress or just to take time out for you. Get ready to reconnect with yourself and let your inner child color with wild abandon.

I have used my own freestyle drawings and Zentangle patterns, combining them to create a fresh approach to coloring for everyone, including adults. Use colored pencils, paint, ink, markers, or any coloring medium you choose. There are some step-by-step instructions included to get you started. Try out color combinations and shading techniques on the pages at the back of this book or just head straight to the 52 drawings and start coloring.

COLOR BASICS

Using color is mostly about choosing combinations that you like. Some combinations will come naturally to you, while you may need to test out others to see whether you like them. At the back of this book, whether you'll find pages where you can try out color combinations with various color mediums. If you don't want to mix colors to create new ones, most sets of pencils, markers, and paints will have a good selection of colors to use without mixing, but it helps to have some knowledge of the color wheel. Let's look at the basics of using colors.

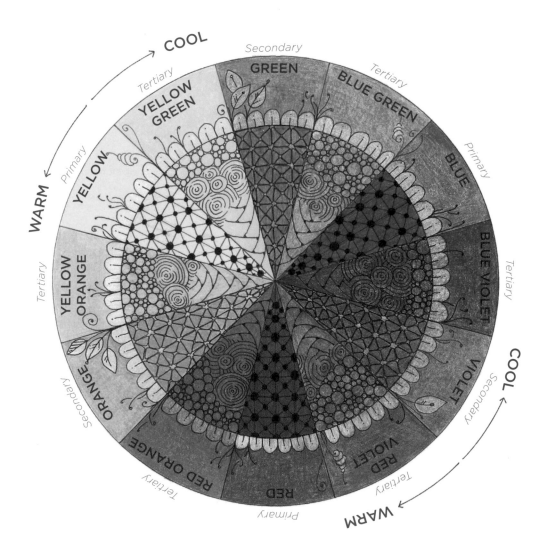

THE COLOR WHEEL

The color wheel looks like a big pie with slices that can be mixed and matched to make different kinds of delicious "recipes."

The three **primary colors**—red, yellow, and blue—are spaced evenly around the pie. These three colors cannot be made by mixing any other colors, but when mixed together in various combinations, they make all other colors.

Secondary colors are made by mixing equal amounts of two primary colors together. The secondary colors are orange, green, and violet.

Tertiary colors are mixed from one primary and one secondary color. On the color wheel, the tertiary colors sit between the primary and secondary colors. They are red orange, yellow orange, yellow green, blue green, blue violet, and red violet.

The colors of the wheel can be viewed as being either **cool** or **warm**. Different emotions and feelings are evoked or portrayed by using various combinations. For example, you might use yellows, oranges, and reds to give a bright and sunny summer feeling to a scene, or blues, softer greens, and violet to portray a cool winter's day.

COLOR TERMS

Hue is simply another name for color.

Tint is a color plus white. The addition of white creates a tint, which is a lighter value of a color.

Tone is a color plus gray. A new tone is created by adding both black and white at the same time. For example: red + white + black = dusky rose (tone)

Shade is a color plus black. The addition of black creates a darker value of a color.

Value refers to the lightness or darkness of a color. One way to show a range of values is by placing different shades of gray (or a color) in stages starting with the lightest and progressing to the darkest. Creating a colored value scale allows you to get used to the amount of pressure of your pencil on the paper required to produce intensity of color. Lighter pressure will create a light value, whereas more pressure will increase the pigment that is being laid down, giving a darker value. You can adjust the amount of pressure by holding the pencil further up toward the end for a lighter pressure or closer down to the point for a firmer pressure.

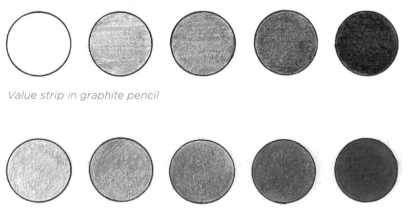

Value strip in graphite pencil

Value strip in colored pencil

The changes in color and value are what make your drawings "pop" and look three-dimensional and more realistic to the eye. It may help to remember that lighter values appear closer to the viewer while darker values appear farther away.

COLOR SCHEMES

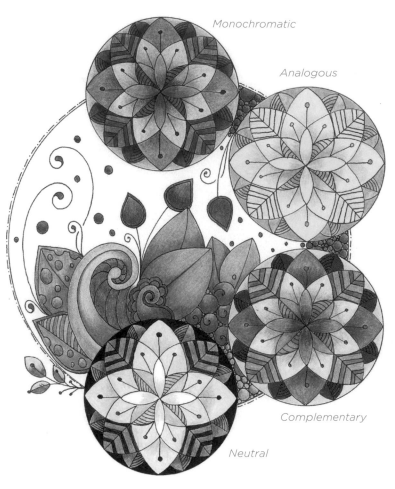

Monochromatic

Analogous

Complementary

Neutral

There are a number of different color schemes, or families of color, that you can play with to create a pleasing look.

Monochromatic is a color scheme that uses any shade, tint, or tone from one color family. For example, you might pick the color blue and choose to use some or all of the blue pencils from your color box.

Analogous is a color scheme that uses colors that are next to each other on the color wheel. Because these colors are related, they blend well together. They sit within a 90-degree angle of each other on the wheel. Examples of analogous colors are yellow/yellow orange/yellow green or blue/blue violet/blue green.

Complementary colors are colors that are directly opposite each other on the color wheel and create contrast. Examples of complementary colors are yellow and violet, blue and orange, or red and green. When you choose a key color, match it with a color of the same vibrancy in the complementary hue. For example, red and green or pink and light green. When the intensity is the same, the colors look balanced. For more contrast and a more dynamic look, use colors with different intensities next to each other, such as red and light green.

Neutral colors are black, white, and gray, but I also like to include beige and off-white.

Practice creating your own color combinations and schemes in the Technique Tryouts section at the back of this book.

MAKING MARKS

Applying marks to paper can be an effective way of creating color and texture with any medium. In the examples, I have used a Faber-Castell Polychromos in Phthalo Blue (9201-110) colored pencil. You could just as easily use a marker or watercolor paints and a brush.

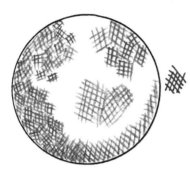

Crosshatching. Use large or small crosshatches with long or short strokes to create different effects.

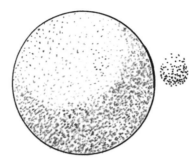

Stippling. Use randomly placed dots to color an area. Dots with more space between them will create a lighter look, whereas dots spaced closer together will create a darker, almost solid look.

Strokes. Use a medium stroke and continue to build up color. Use fewer strokes to make an area lighter and more strokes to make an area darker. You can also vary the length of the strokes to create a more uneven finish.

Scrumbling. This technique of creating a pattern using squiggly lines lends an almost lacy effect to your coloring. Build up the scrumbles on top of each other for a darker look. You can also use different levels of pressure to create light and dark variations.

Try some of these methods in the Technique Tryouts section at the back of this book.

STRAIGHT COLORING

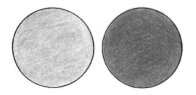

Straight coloring is when you use one color in an even layer over the entire area. In the example, I used one solid color to fill the circle. Use small circular movements with a sharply pointed colored pencil and even, light pressure. Start at the top left-hand side and continue to evenly apply color to the whole area. You can go back over the entire area using a slightly firmer pressure to color in any areas that are still showing through. You can see the second colored circle is much darker than the first, and you can't see the paper through the color. I used a Sanford Prismacolor in Hot Pink (PC993).

LAYERING COLOR

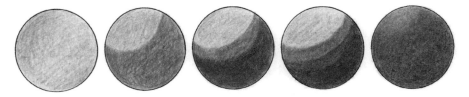

Layering is when you use a number of colors on top of each other. In the example, I started out with the lightest color at the top left and graduated through to the darkest.

Using small, circular movements with a sharply pointed colored pencil, layer the first color over the whole piece. Lay down the second color over all but a small area that is left as a highlight. Apply the third and fourth colors in the same manner, leaving a little of the previous color showing through. In the last circle, I went back in with each color and softened the lines where one color meets the other, making them slightly overlap into each other. I then went over the whole circle with the lightest color to blend and finish off. I prefer to use three or four shades with this layering technique because it gives the finished drawing a wonderful three-dimensional effect. I have used Faber-Castell pencils in Pink Madder Lake (9201-129), Fuchsia (9201-123), Crimson (9201-134), and Manganese Violet (9201-160).

SHADING

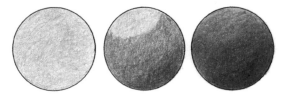

Shading is a combination of straight color with a darker layer on top to indicate shadow and light. Start by using small, circular movements with a sharply pointed colored pencil and even, light pressure. Color in the whole area with the lightest color. Next, add a darker color to create shading. Don't forget to be consistent in where your darks and lights fall on the whole project. For example, imagine a light source up to the top left of a page; all the highlights, or lighter areas, will fall on the top left while the darker shading will be on the bottom right of each piece to be colored. In the example, I colored in the whole circle as I would using the straight coloring method. Then, to add shading, I layered the darker color on the bottom right side, gradually increasing pressure and making the color darker as I moved toward the bottom. I then went in again with the lightest color and applied it to blend where the light and dark meet to smooth it down. I used Sanford Prismacolor in True Blue (PC903) as the light color and Peacock Blue (PC1027) as the dark color.

Note on shading: Often tangle patterns are drawn one behind the other. If you shade the object behind darker where the front object overlaps and then use a lighter color in the other areas, you will create more definition and the appearance that the objects behind are receding. This method also adds depth to the image.

COLORED PENCILS

Colored pencils are made of pigments that are combined with either a wax or oil binder and then encased in wood. There are many brands of colored pencils available. Try them and choose the best you can afford. If you want your work to last with minimal fading, use colors that have a high lightfast rating. Most brands of artist's pencils will have different ratings of lightfastness, and you can usually access this information on product websites. Pencils also vary in the level of hardness. Oil-based pencils provide lighter, more delicate coverage but will allow more layers of color on color. These harder pencils can hold a point longer, thus requiring less sharpening. Softer wax-based pencils blend well and you can put down a heavier, thicker layer of color depending on the level of pressure you apply with the pencil.

A set of twelve pencils will be enough to get you started. Larger sets will have more variation in tint, tone, and shades. Often you can buy single pencils and add to your collection one at a time.

USING STRAIGHT COLOR PENCILS

Straight coloring, as noted previously, is when you use one color to lay down a nice even layer of colored pencil in an even stroke. This is the easiest method and you can go back in later and add a darker color to shade if desired.

BLENDING AND SHADING COLOR PENCILS

Lighter colors are more transparent and the darker colors will give more coverage. I like to start with a layer of the lightest color and build up to a darker color where I want shadows. You can continue to build up layers to increase the density.

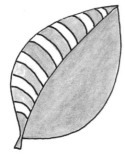

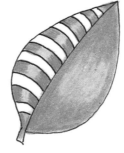

Light cover of the lightest color.

Add darker color at the tip, bottom, and side to create shadow and a three-dimensional look.

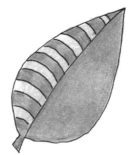

Go back over with the lighter shade to blend to a softer gradient.

WATERSOLUBLE COLORED PENCILS

Watersoluble colored pencils are widely available and most of the major brands will have them. A light coverage of the dry pencil on paper is the easiest way to use it.

Starting with the lightest color and using a light, even pressure, color in the area. In the top example, I left the center of the leaf free of color so the color can be blended and pulled into this area with a wet brush. You can use either an Aqua brush that has a water reservoir that can be squeezed to release a drop at a time or a round paintbrush dipped into clean water. Use a paper towel to remove excess water, as the brush needs to be only damp, not saturated. Place your brush on one side of the drawing and pull the color into the center.

When this layer is dry, apply a darker shade of the same color to create your shadow area. On the leaf, I darkened the tip, bottom, and along the center line as well as the top and Faber-Castell Polychromos Phthalo Blue (9201-110) along the bottom curves of the stripes. Once again go in with a wet brush and blend the darker color into the lighter color. Be careful not to overpower the highlights with darker colors. You can wipe off your brush with a paper towel to remove excess color.

You can also layer the light and dark colors at the same time, blending them with the wet brush, rather than waiting for one layer to dry. See which method you like the best by trying it out first.

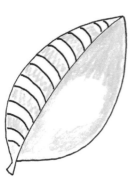

Apply a light layer of color

Using a wet brush, smooth the color into the edges and into the center

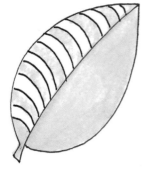

Apply a darker shade of dry color

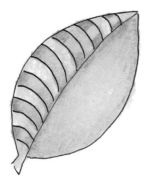

Blend the darker color

INKTENSE WATERSOLUBLE INK PENCILS

Although you can use Inktense pencils by Derwent in the same manner as watersoluble colored pencils, they are in fact watersoluble ink. The colors are vibrant and permanent once dry.

Inktense pencils can be colored directly onto the paper or you can use a wet brush to "lift" color off the pencil and apply that to the paper. Alternatively, you may use your wet brush to pool the color off the end of the pencil onto a piece of clear acetate or a piece of glass. This is a useful method if you want to mix colors. It can also be used to create pastel colors by simply adding white to the color. Lift these mixed colors off with a brush and apply them to the paper just as you would with paint. If you have too much color on the brush, lightly touch the tip of the brush to a paper towel. Once the drawing is dry, you can apply more color over the top without disturbing what you have already done.

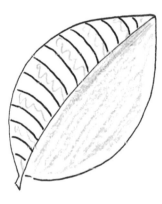

Apply dry Inktense color to the paper

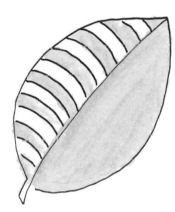

Use a brush to wet the color

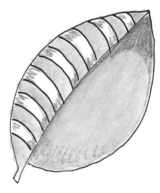

Apply a darker shade to the dry drawing

Use a brush to blend the darker color for shading

COLORED MARKERS

Sakura Koi Coloring Brush Pens have a wonderful range of colors. Sakura also offers a colorless blender pen. I find blending color on the paper can distort the paper. Instead, I like to apply the particular color onto a piece of acetate or ceramic tile and pick up the color with the blending pen. This method allows for a smoother application and gradation of color.

Faber-Castell Pitt Artist Pens are also wonderful to use. I have successfully used them with the Sakura Koi blender pen. Apply the Pitt pen color to a piece of acetate or ceramic tile and pick up the color with the Koi clear blender and apply to the paper.

Faber-Castell Connector Pens, which are felt-tip pens, are a favorite for applying straight color to paper. This brand offers a great range of colors, and the pens are fairly inexpensive.

Apply light-colored marker

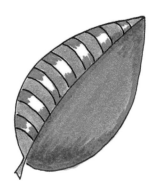

Apply a darker shade where the shadow will fall

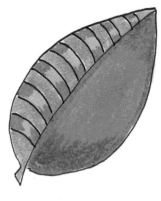

Apply the lightest color to highlighted areas

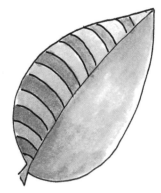

Use the Sakura Koi Brush Pen to blend colors

LIQUID ACRYLIC INKS

If you don't have a paint palette, use a white ceramic dish or plate that is reserved for painting only. A little ink goes a long way. Daler-Rowney FW Acrylic Artists Inks have an eyedropper in the lid of each bottle. I prefer to place only a few drops of one color and use that first. If it dries out, wash the ceramic dish and start with a fresh batch of color, otherwise you may get fragmented dried pieces in your brush. Acrylic inks work best if they are applied using the straight color method. They can be mixed on a palette prior to applying to the paper.

A size 000 brush is good for creating small lines and making marks as well as getting into tiny spaces. Use a larger 01 flat brush for bigger areas.

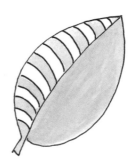

Apply the lightest color first

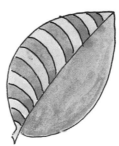

Apply a darker shade for areas of contrast

WATERCOLOR PAINTS

Watercolors come in pans or individual tubes. Paints in pan form can be used directly from the pallet in which they are packaged, and include twelve or more colors. If you are using watercolors from a tube, squeeze a little out onto a pallet. I like to separate my colors like the color wheel for easy use. Once again, if you do not have a paint palette, just use a ceramic dish or plate that you reserve for painting only. Apply the lightest shade to the area you are coloring and then add the darker shade. The more water you add to the watercolor paint, the lighter and more transparent the color will be. If you add white, the color will be softer and more pastel-like. If you add black, the color will be deeper.

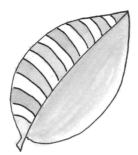

Lightest color washed onto leaf

Darker shade applied to the bottom of leaf

Darker shade applied to stripes and darker application along the leaf stem

BACKGROUNDS

Sometimes I want a softer, less defined background on a coloring page. Both pan pastels and pencil pigment shavings work nicely.

PAN PASTELS

Pan pastels are a good option if you want to cover a lot of background with a little color.

Blend the pastel with a soft sponge applicator and mix colors for a dappled look. You can also use a nonscented tissue or a soft cotton ball to apply color. A little pan pastel goes a long way, so start with a small amount and add more if needed. You may be able to achieve the same effect with pastel pencils. Use an emery board to file off some of the pastel pigment onto a dry surface and pick it up with your choice of applicator.

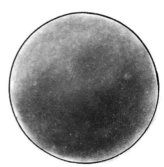

Blended pan pastels

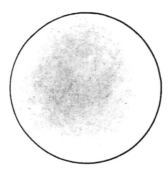

Sanford Prismacolor Pencil grated and blended with tissue

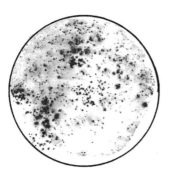

Derwent Inktense Pencil grated and sprinkled onto wet paper

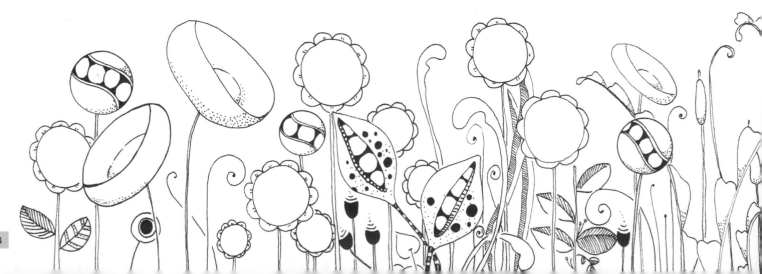

PENCIL PIGMENT SHAVINGS

Using a piece of fine mesh, a mesh tea strainer, or an emery board, grate a pencil onto a dry surface separate from the drawing. The resulting color particles can be applied to the paper with a soft tissue, sponge, or cotton ball. If the paper is lightly wet, the particles will spread out when sprinkled, creating a speckled effect. Only wet the area you wish to color. The particles will brush off the dry areas.

If you wish to retain white space, apply an artist masking fluid beforehand. The masking fluid is latex and will simply rub off with your finger or a soft eraser, leaving the white space intact.

Backgrounds can also be colored with Inktense pencils or other color may be applied over the top once dry without any ill effect.

HIGHLIGHTS

Highlights can be made using a white gelly roll or a Uni-ball Signo white gel ink pen. Try a few brands to see which one works the best for you. A white-colored pencil can also be useful for softer highlighting and will work over any of the mediums discussed in this book.

Highlights made with a white gelly roll pen on colored pencil

Highlights made with a white gelly roll pen on colored marker

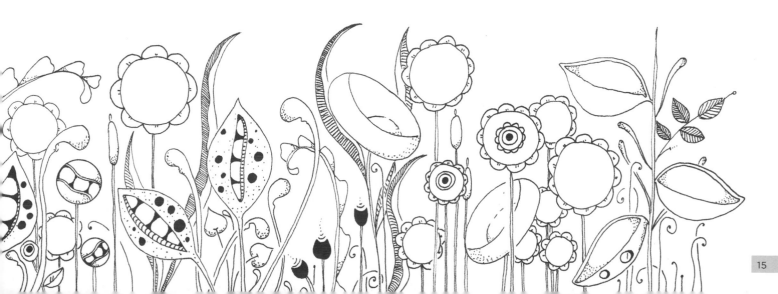

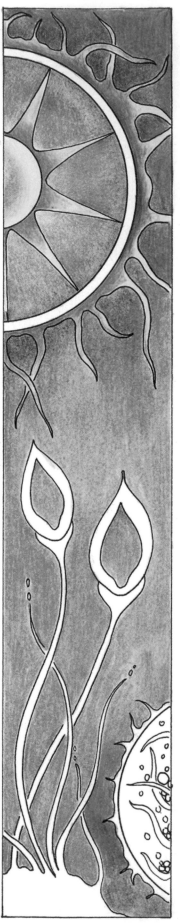
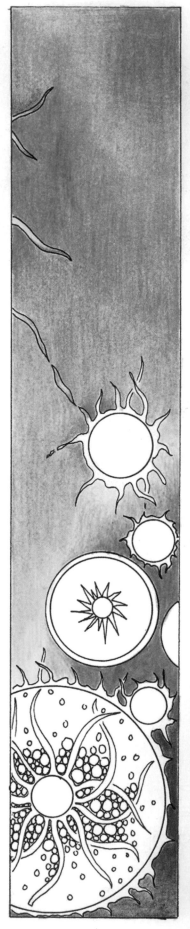
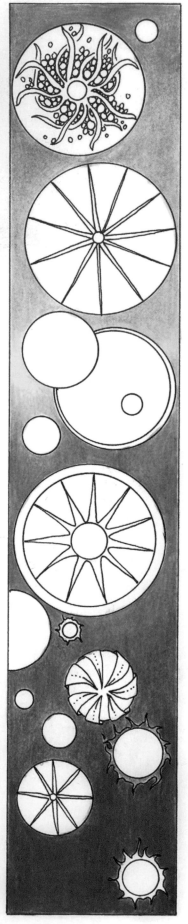

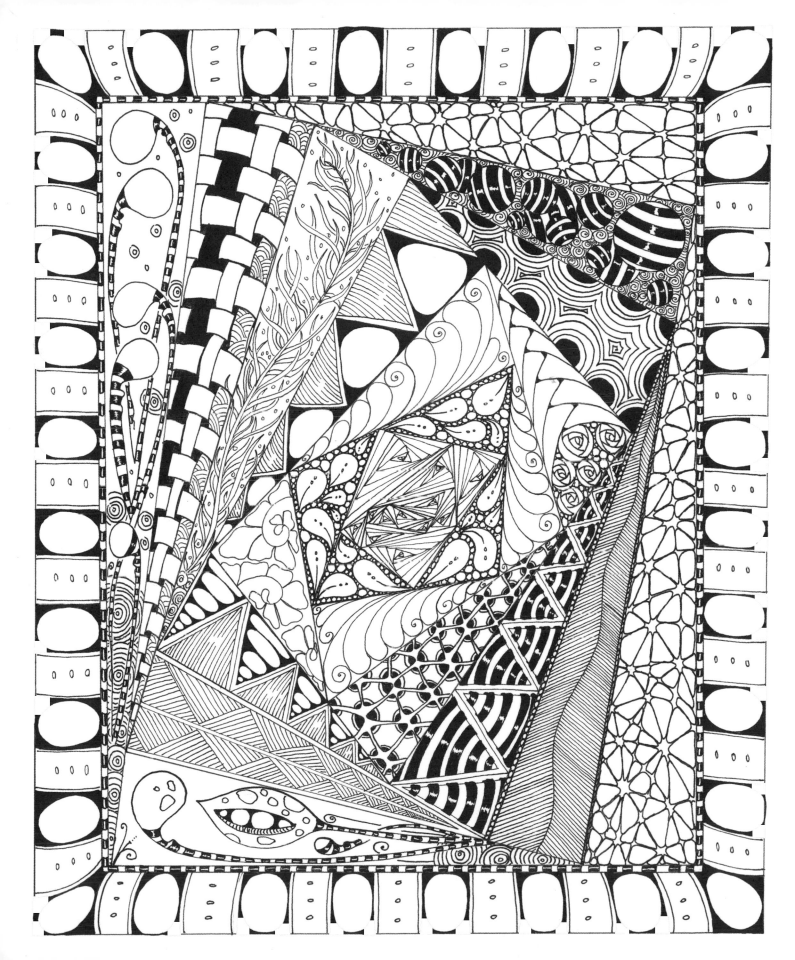

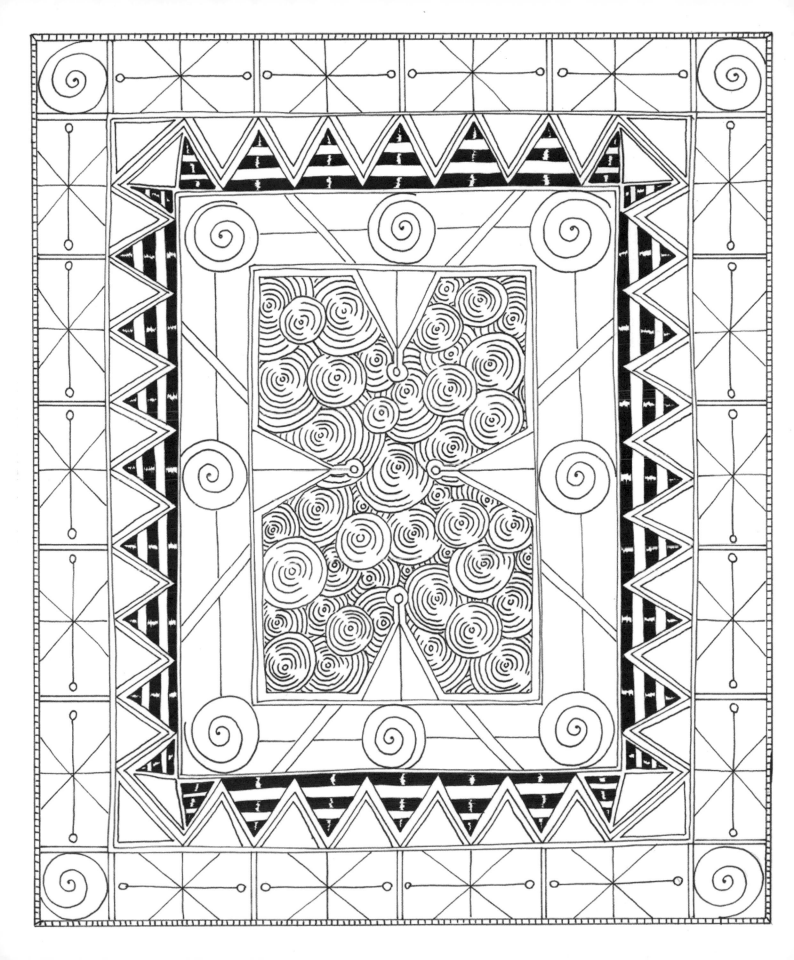

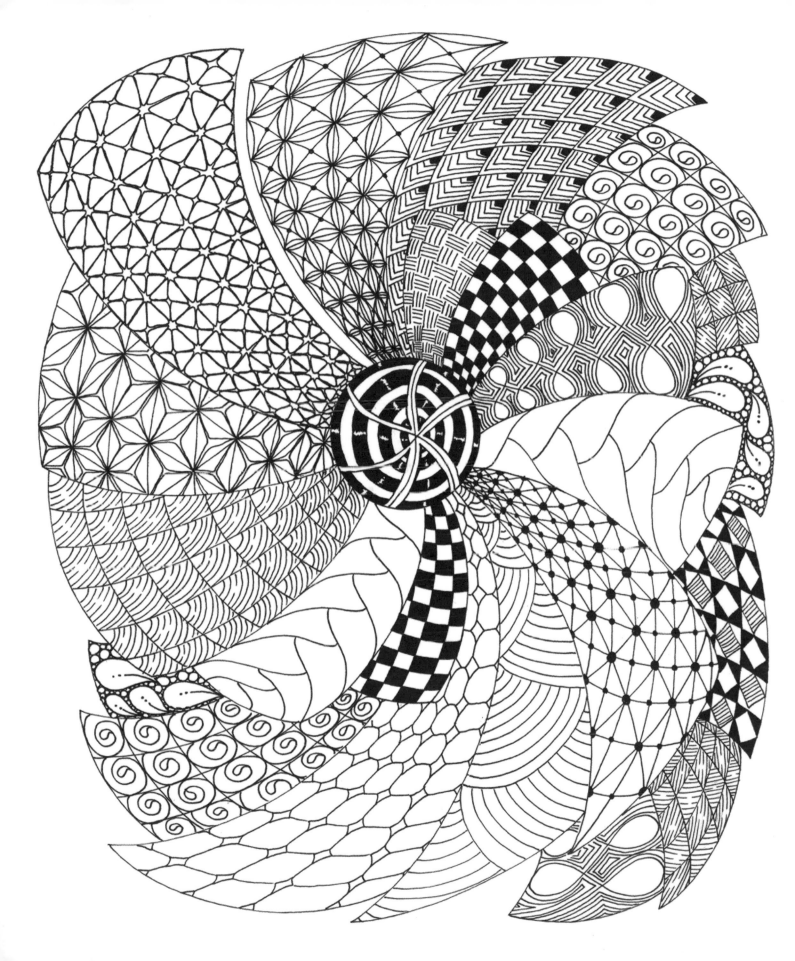

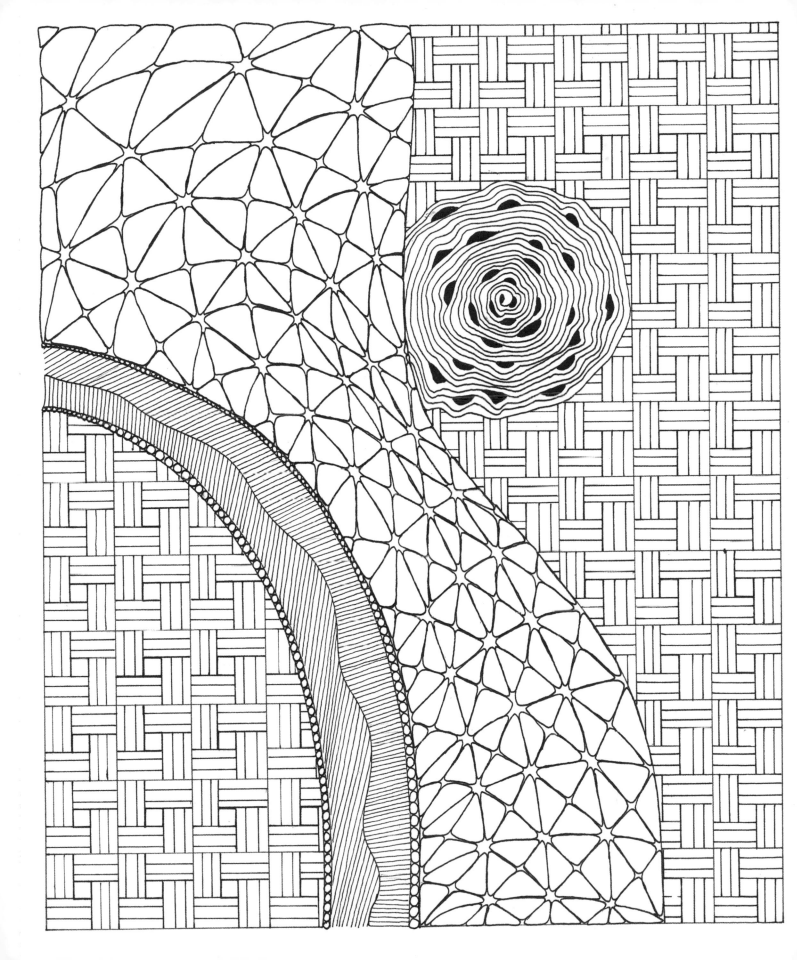

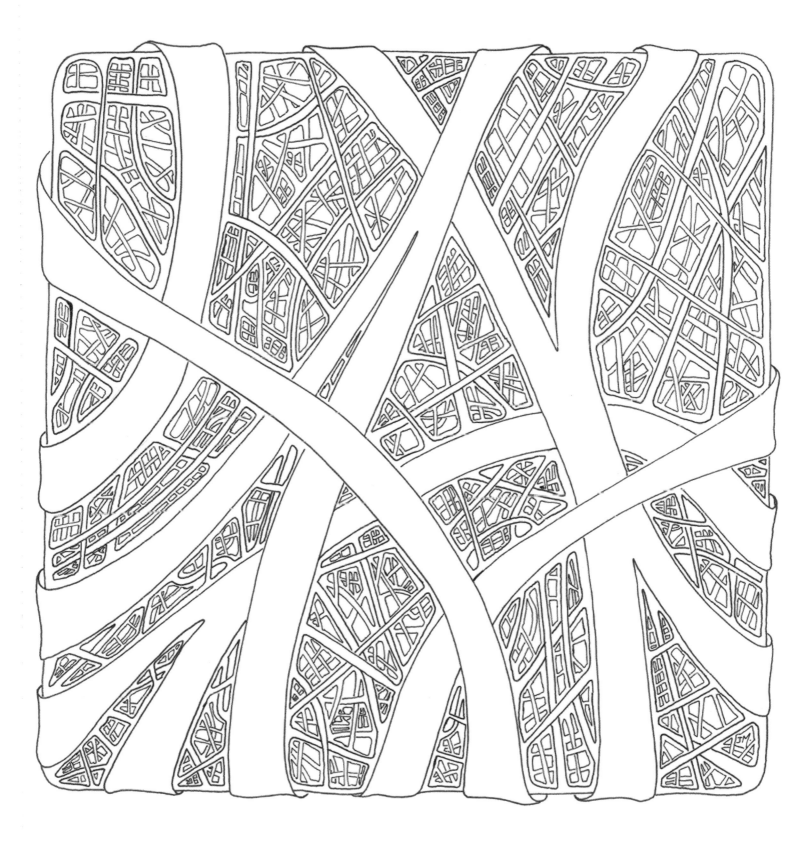

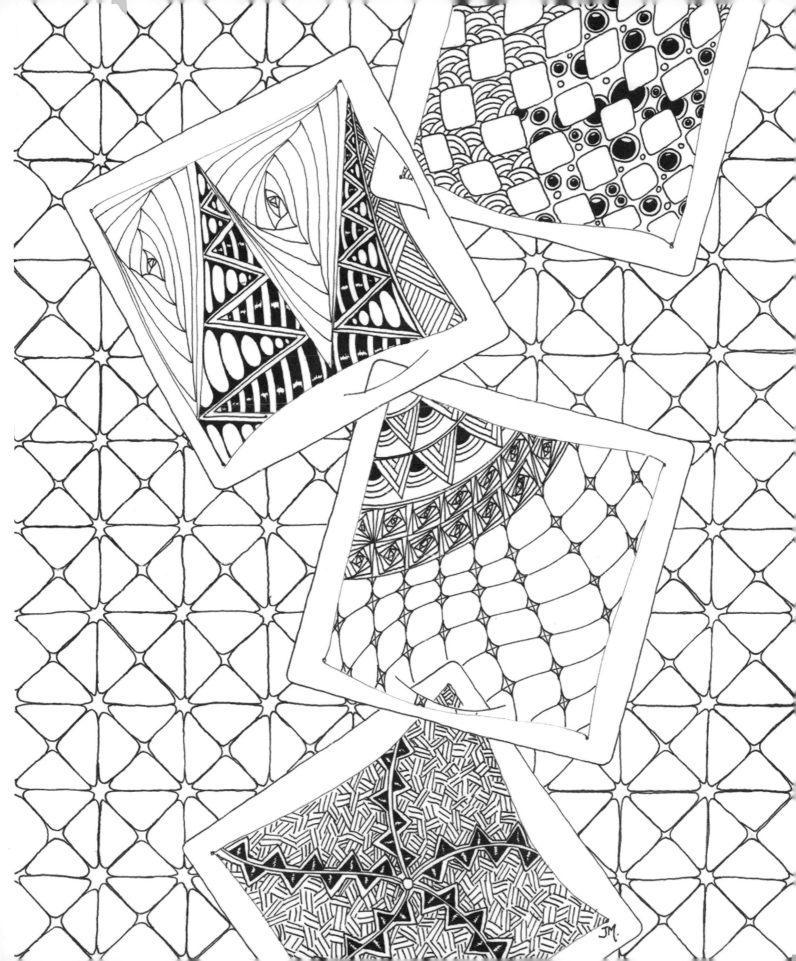

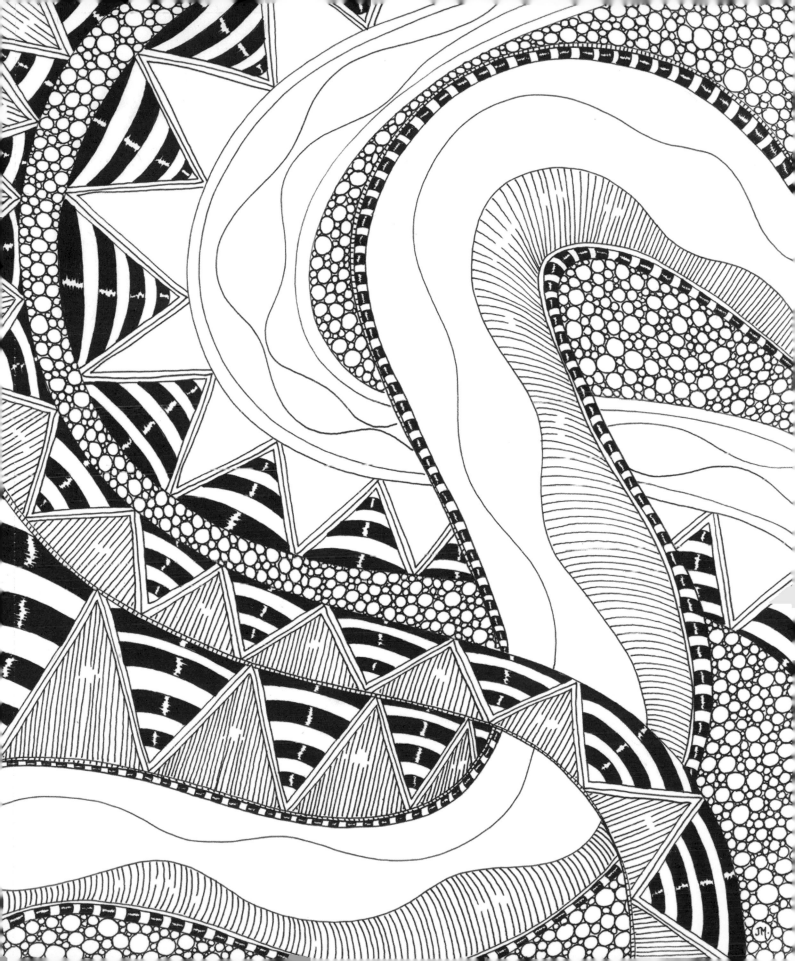

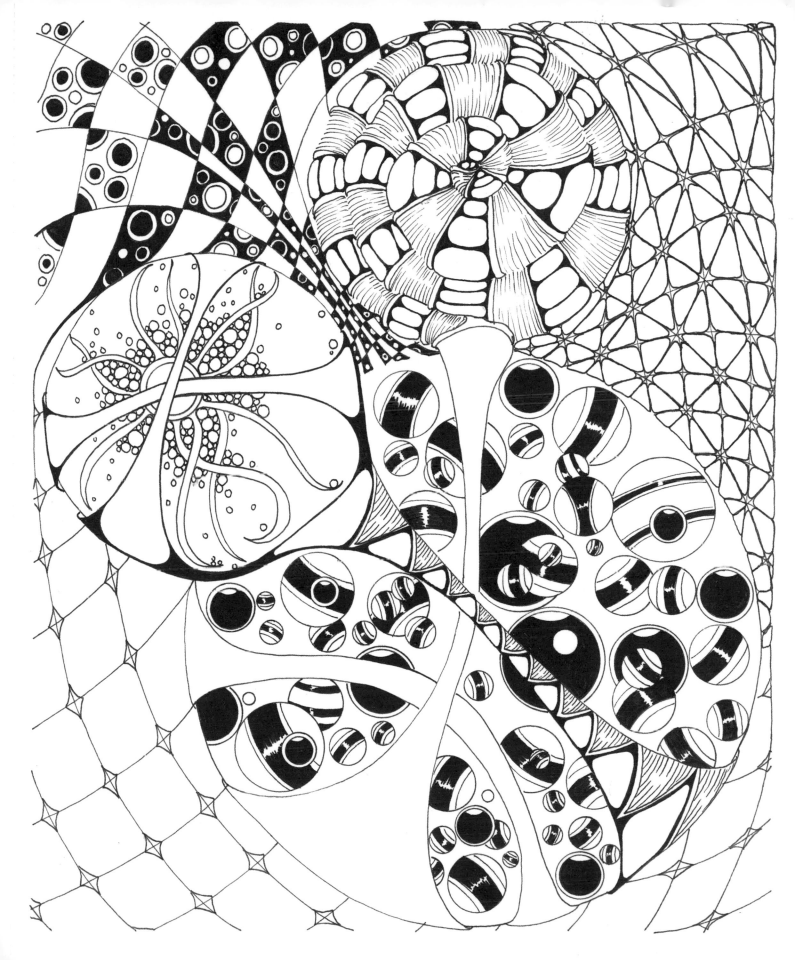

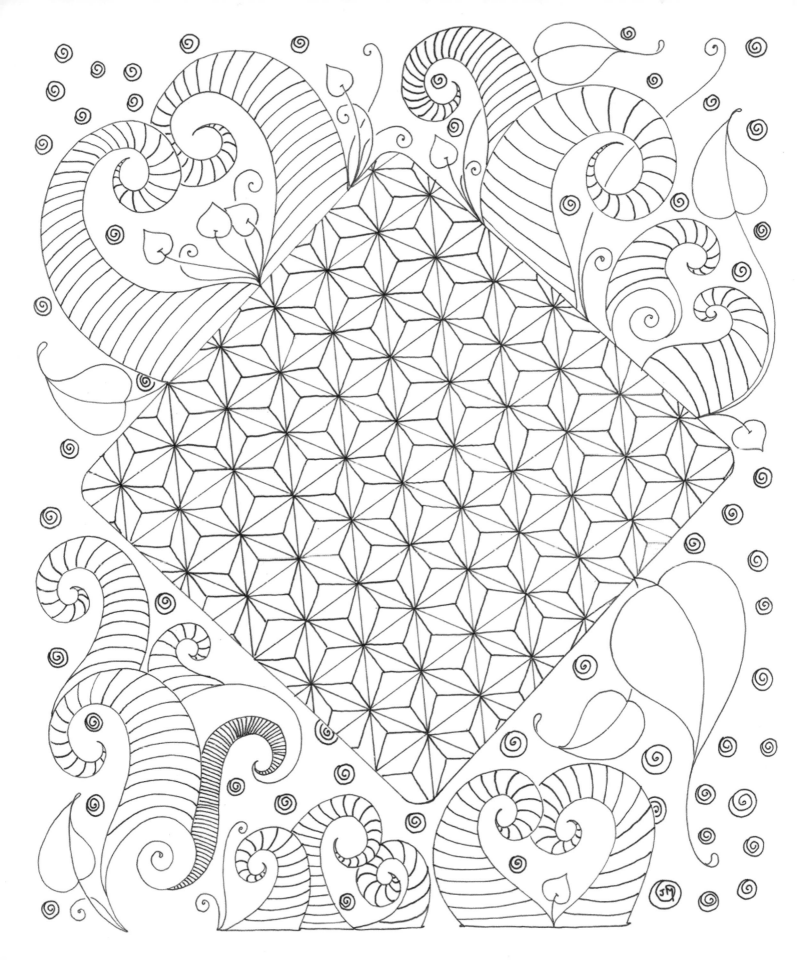

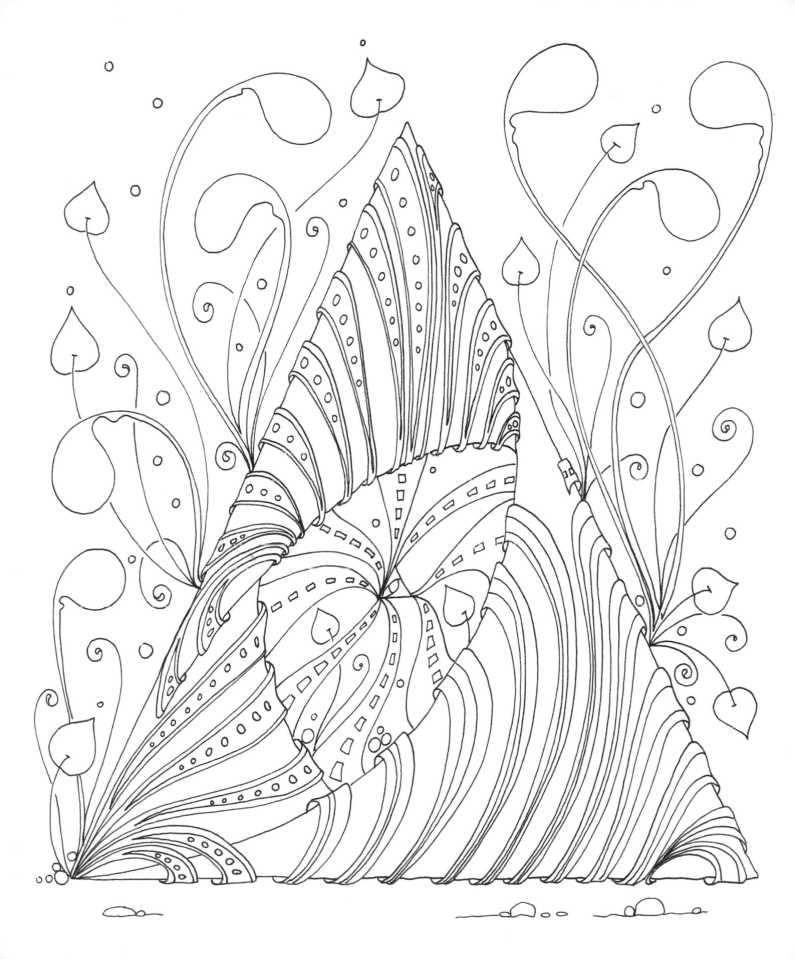

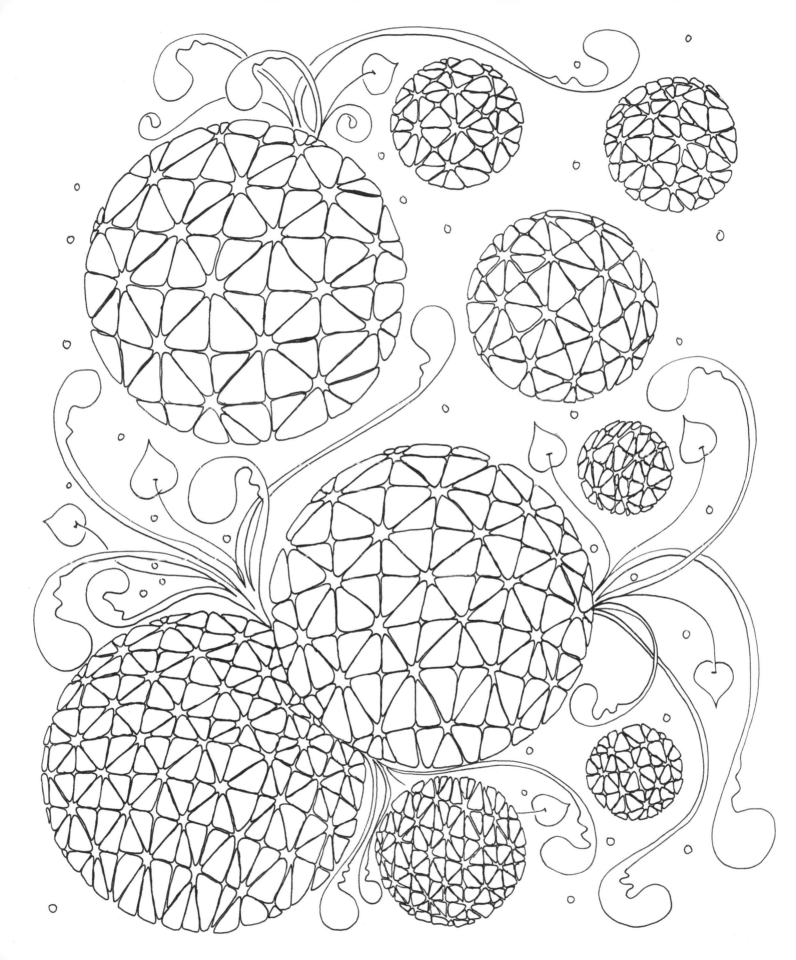

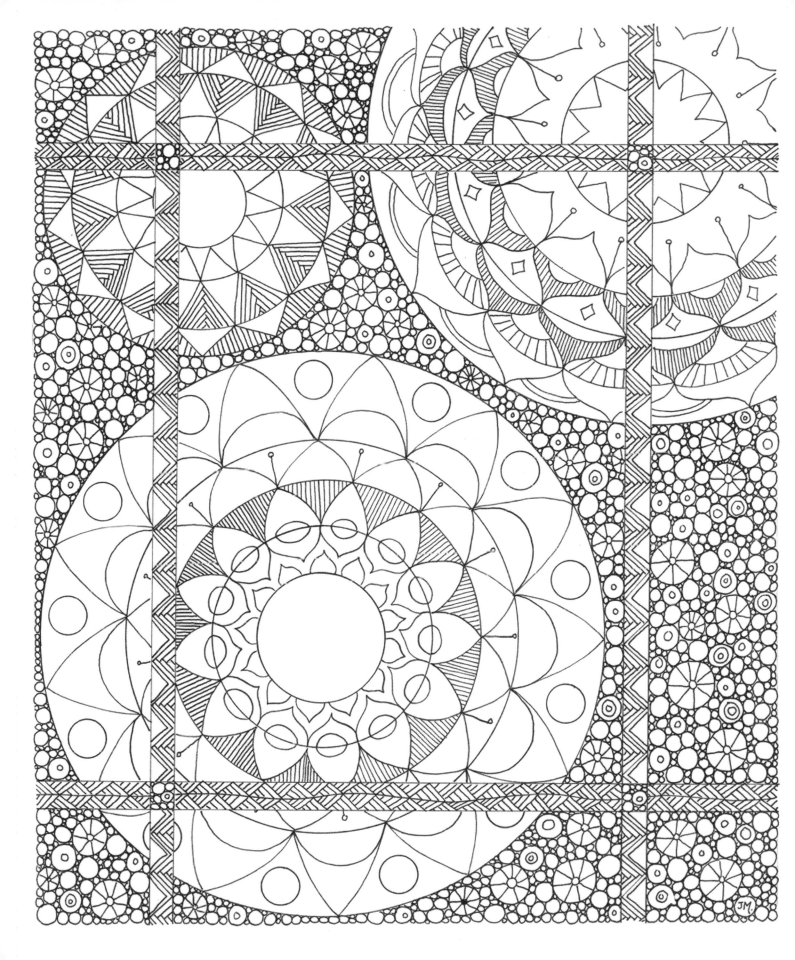

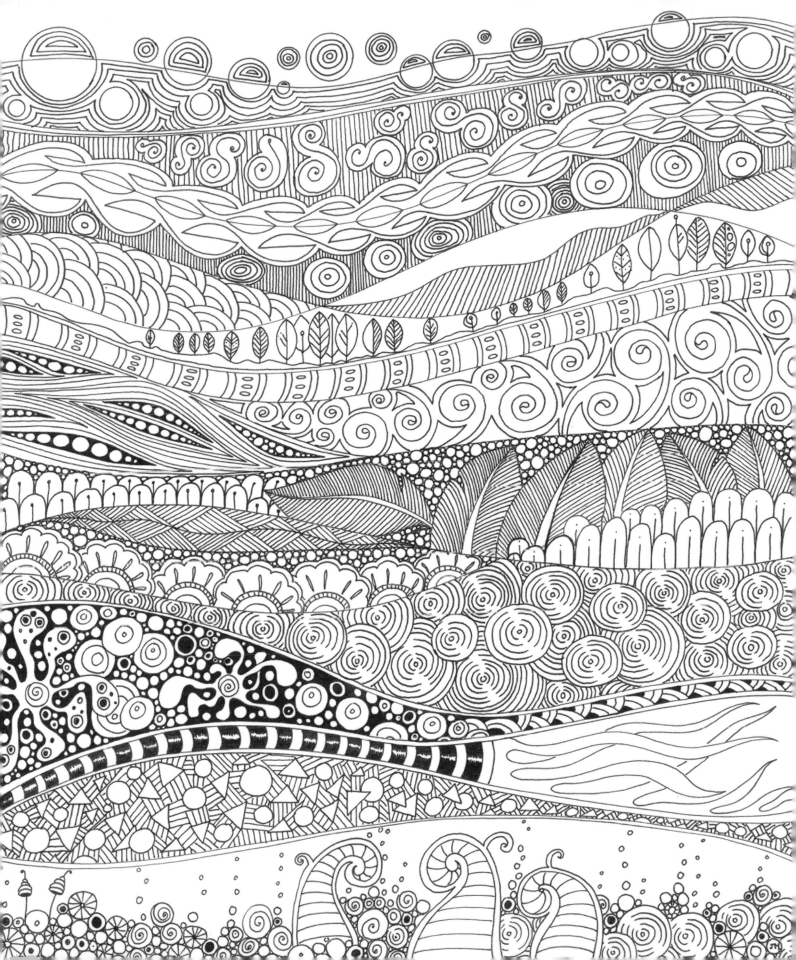

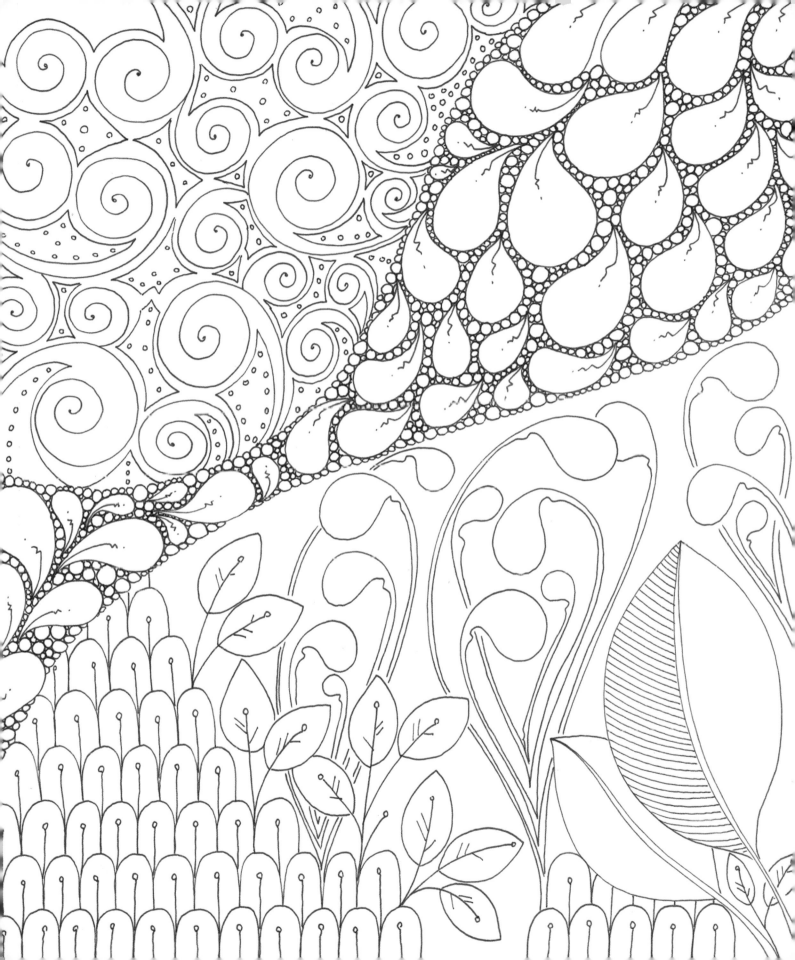

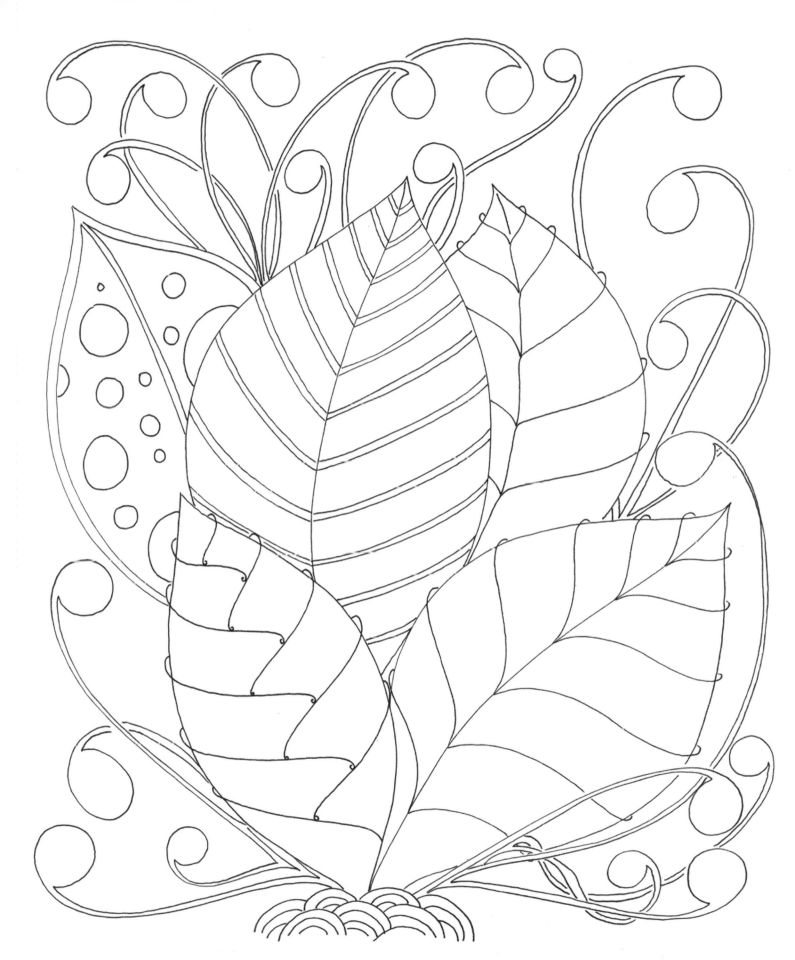

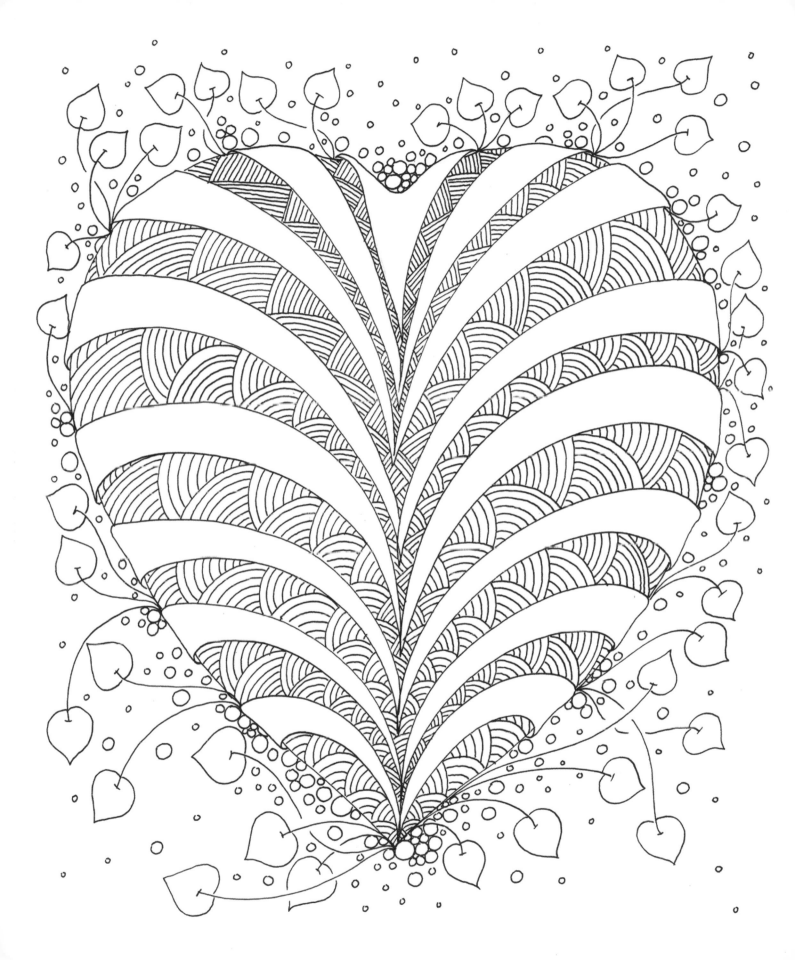

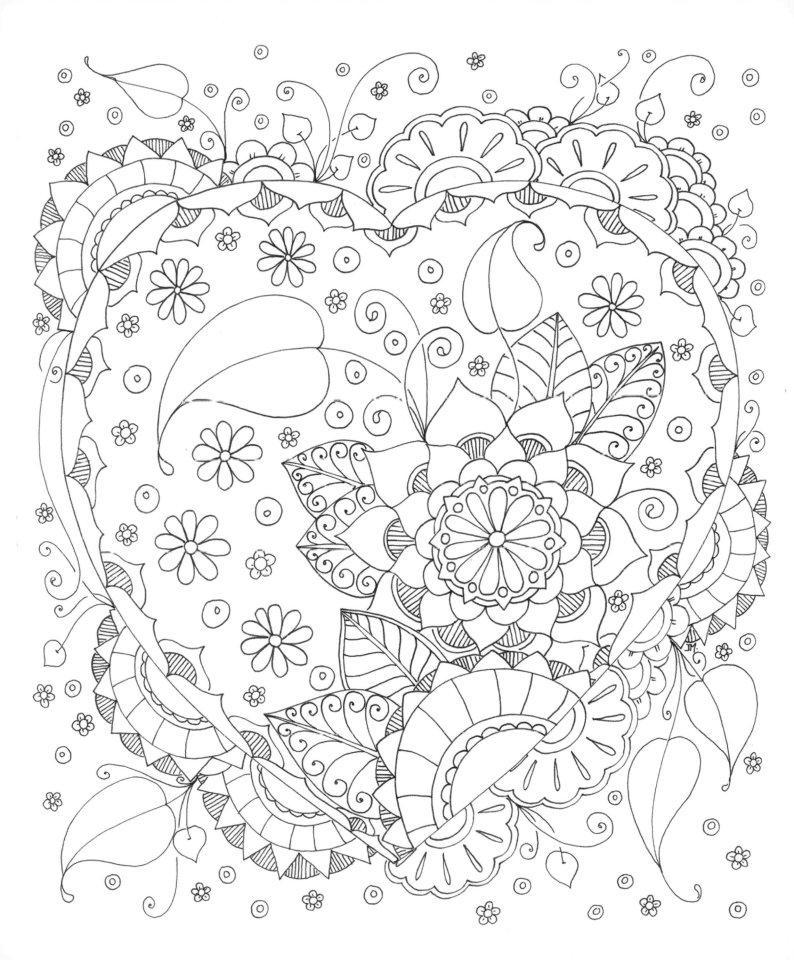

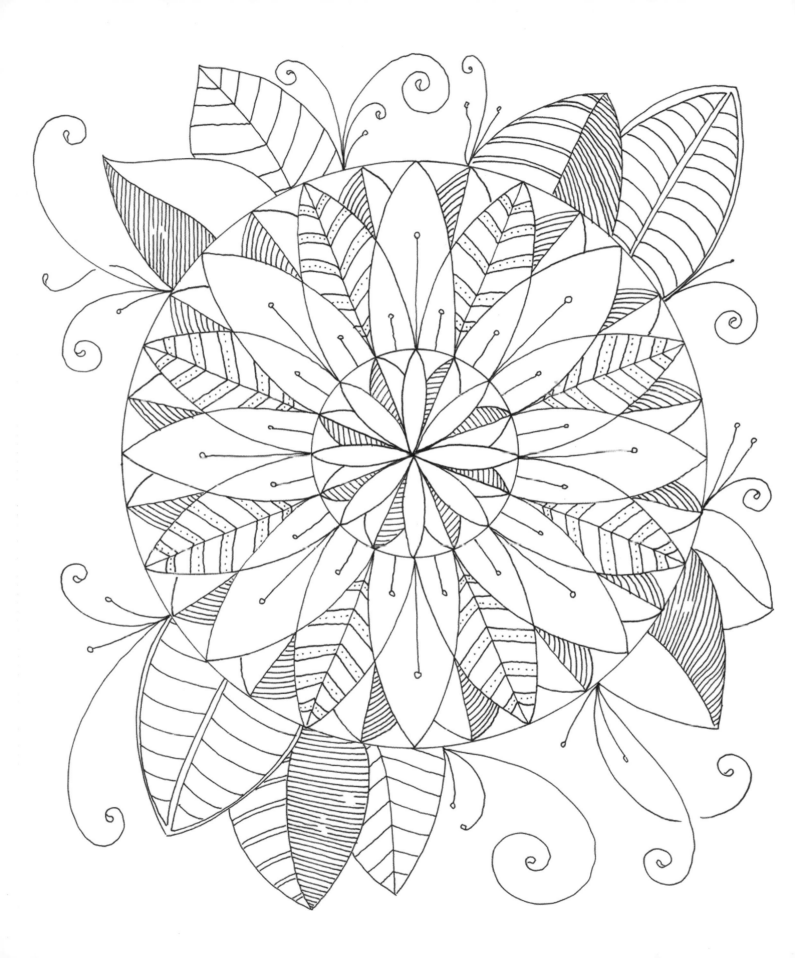

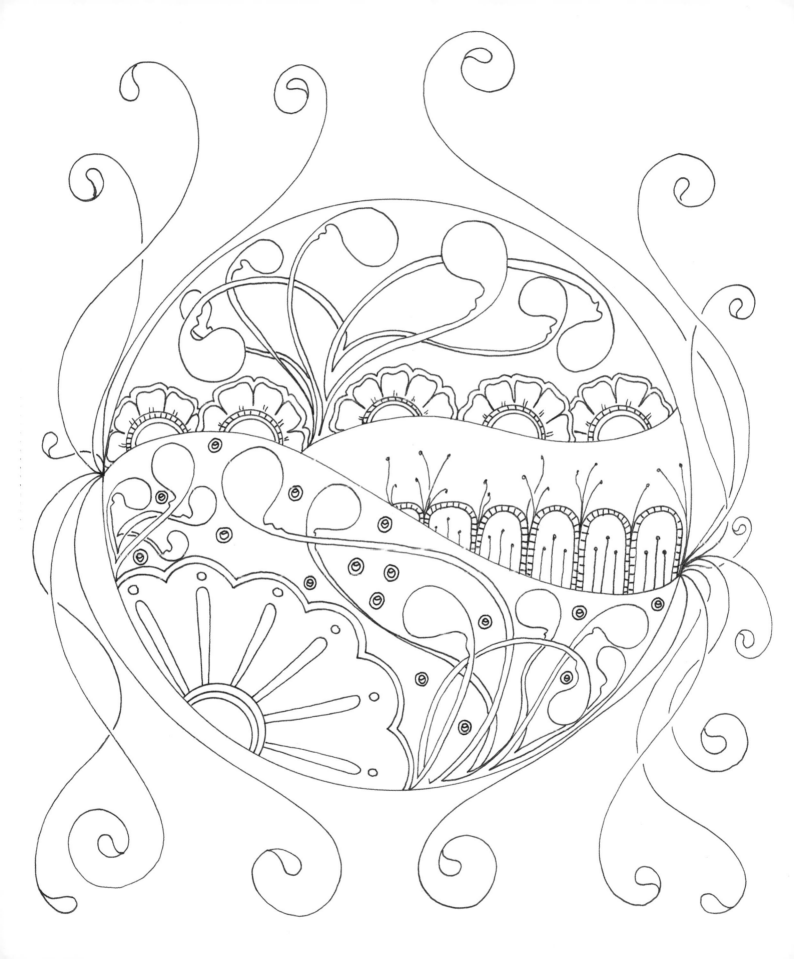

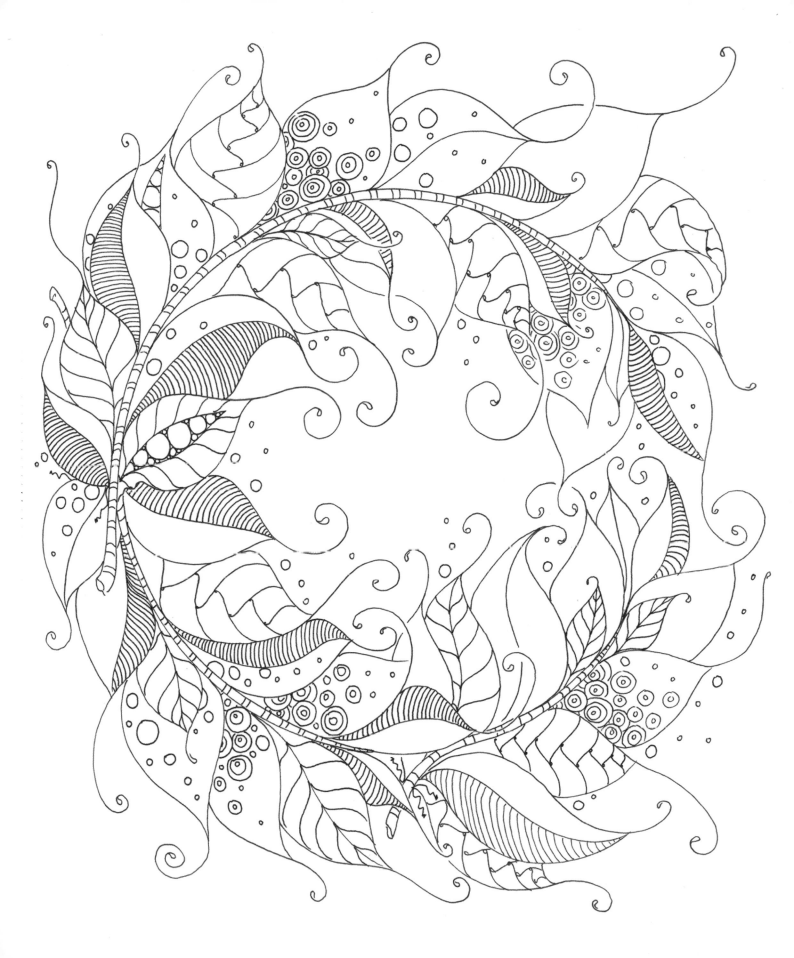

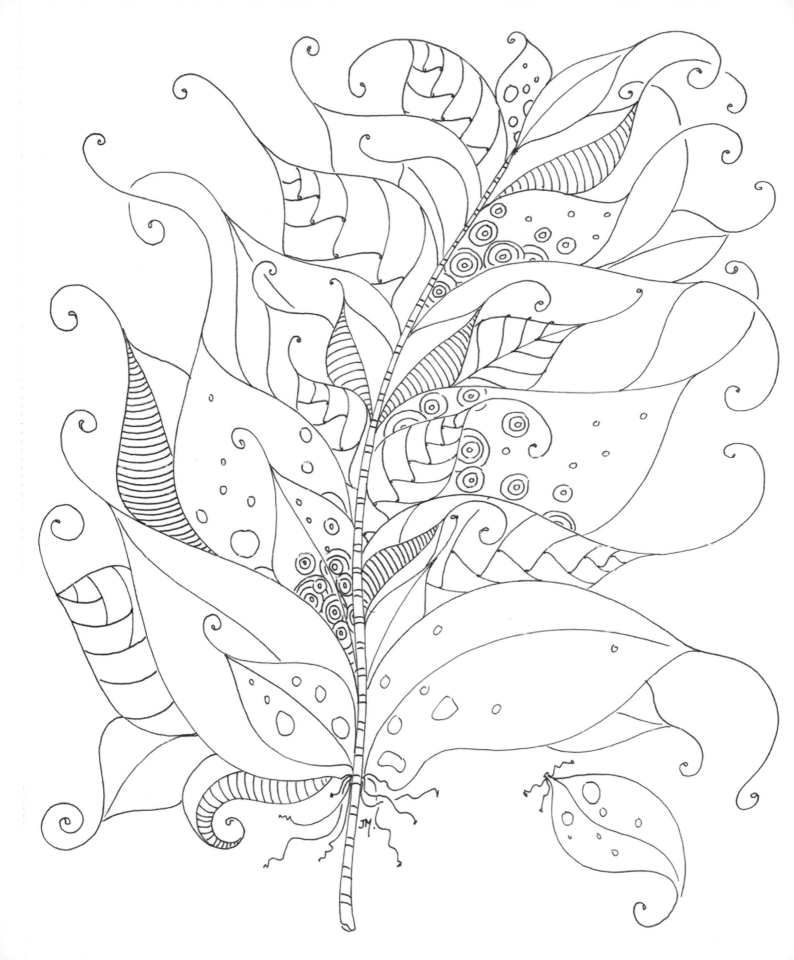

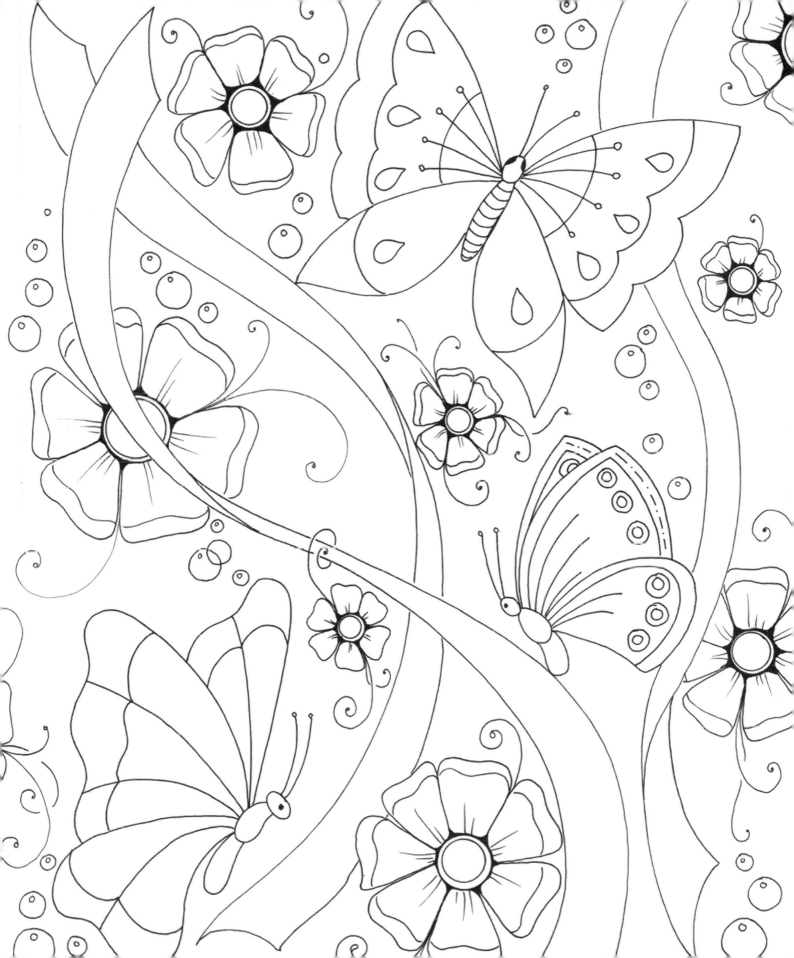

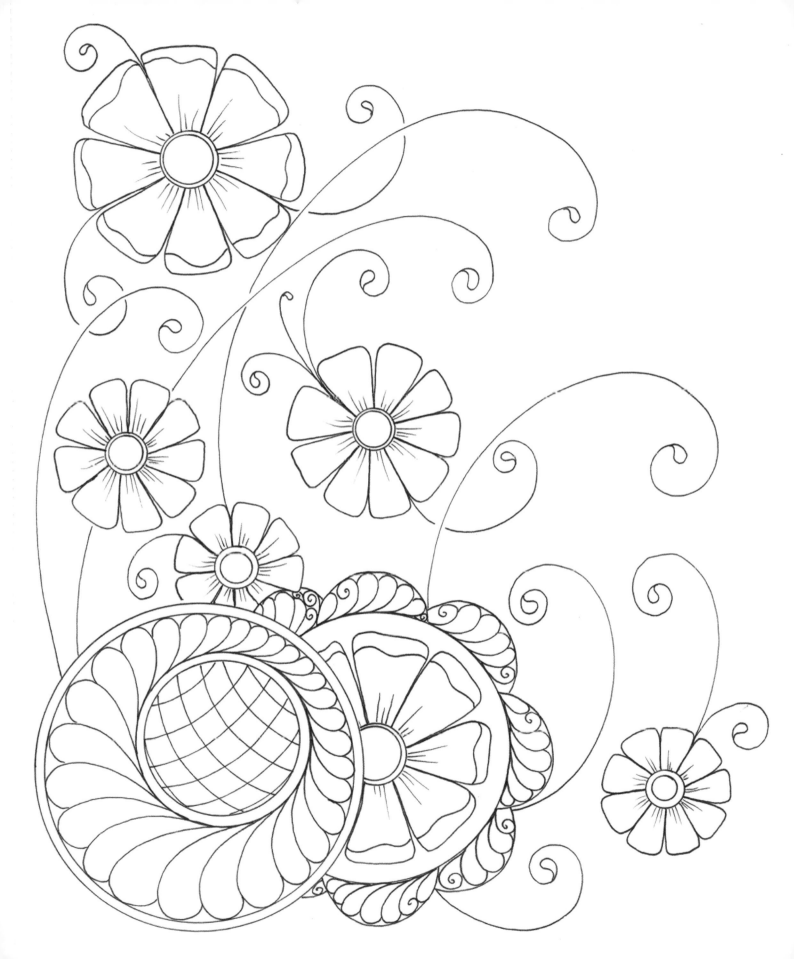

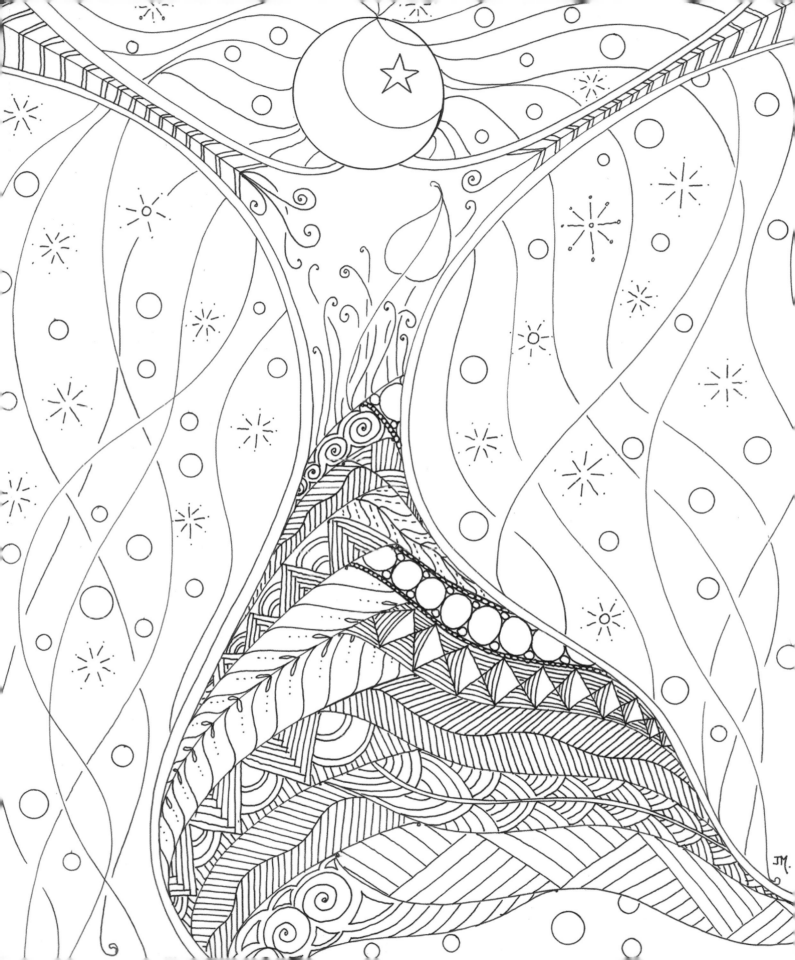

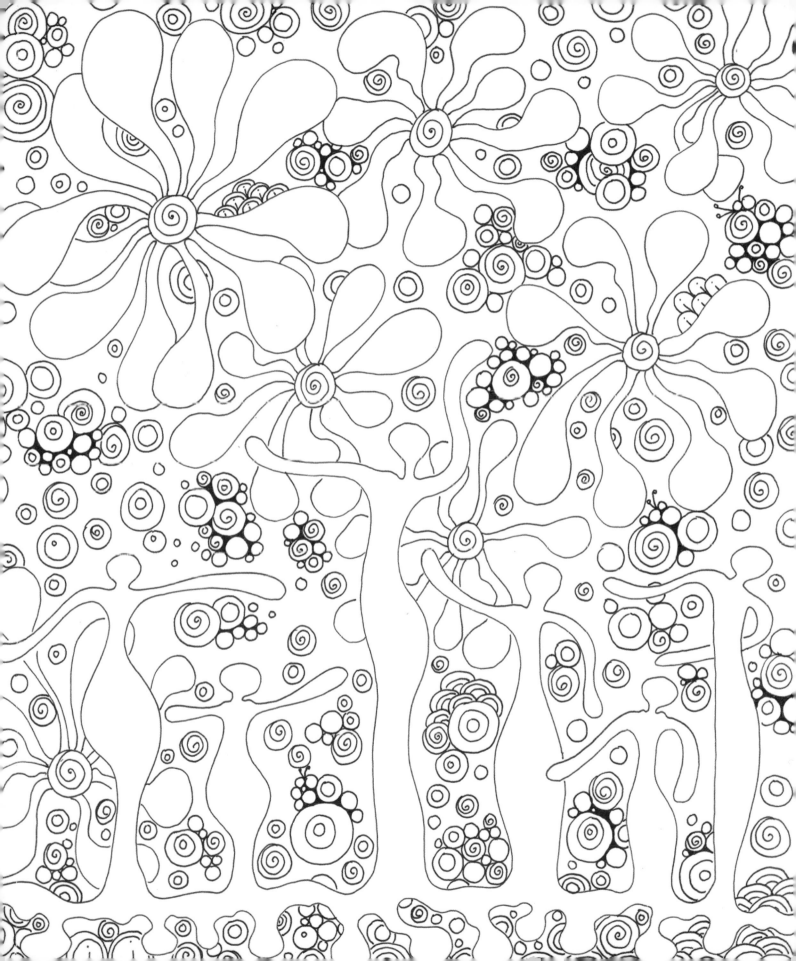

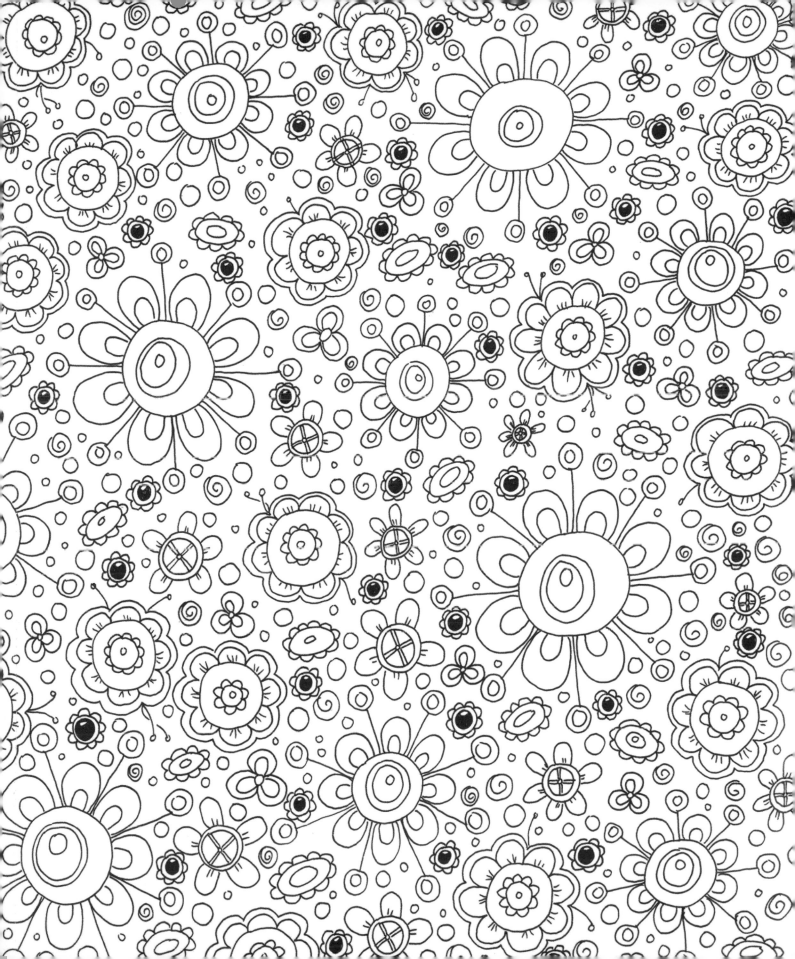

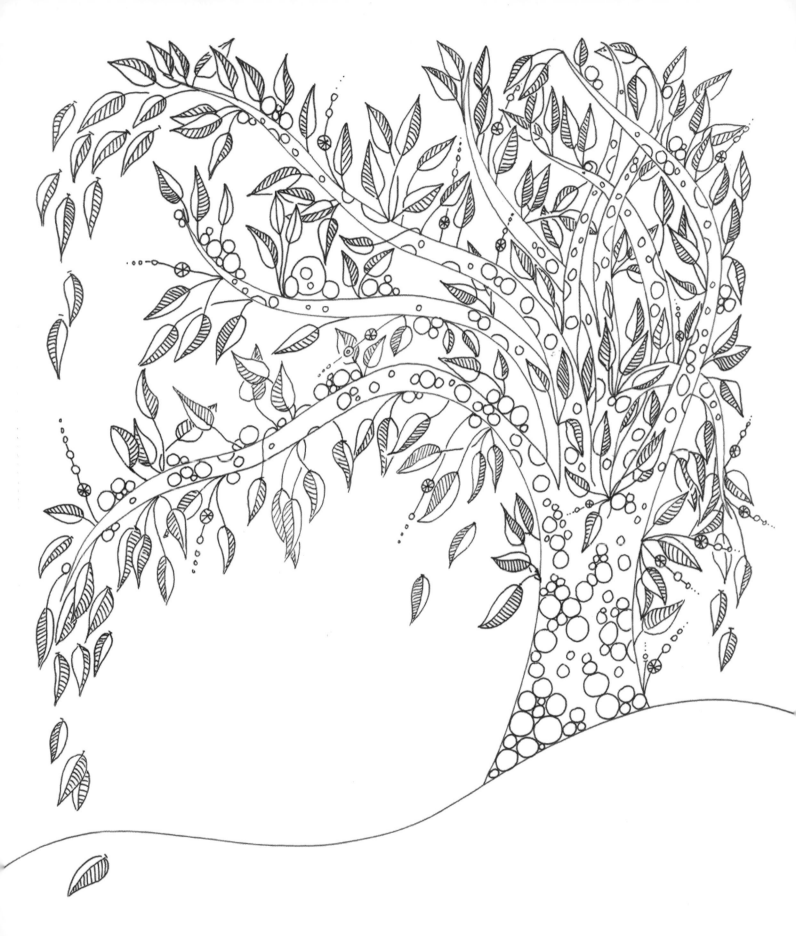

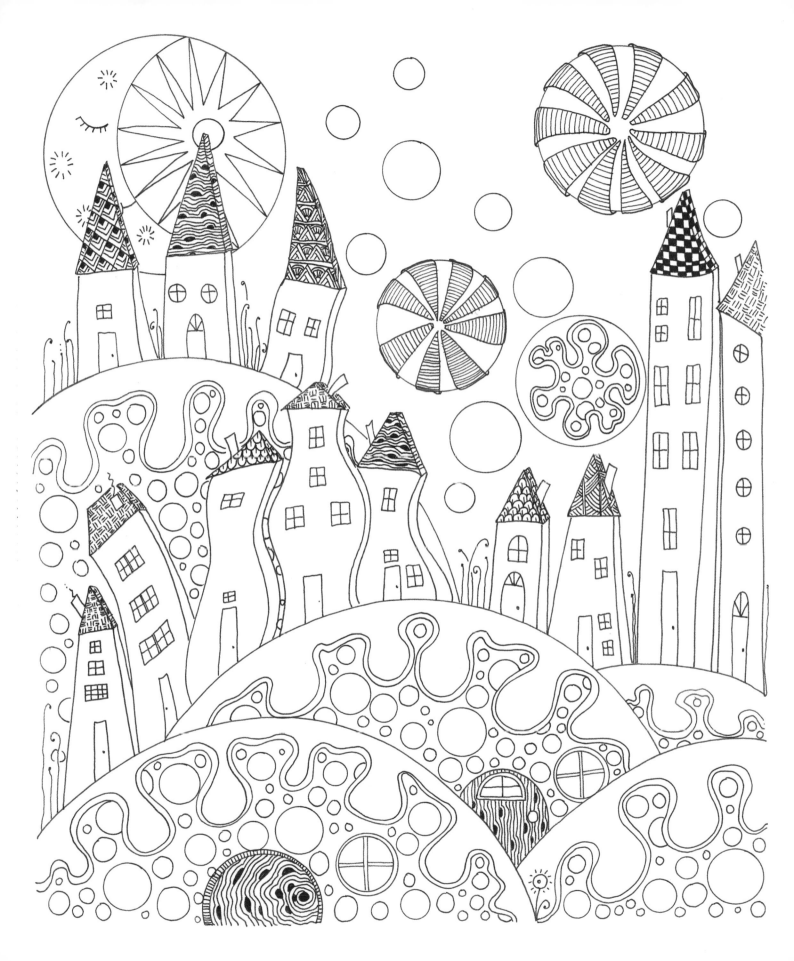

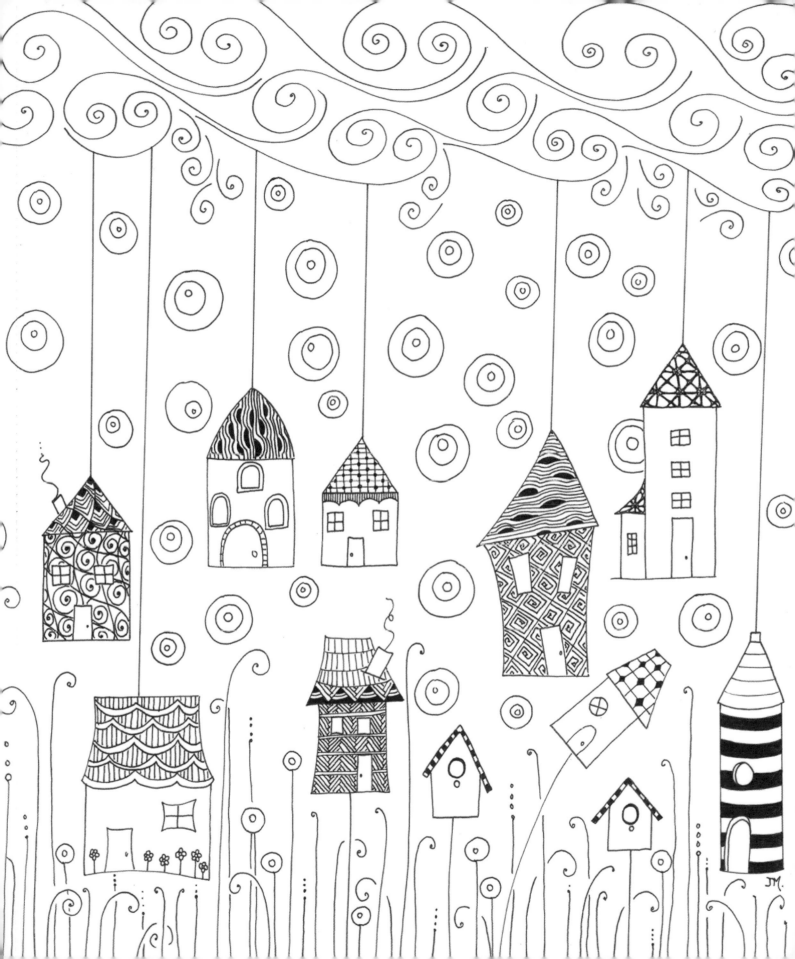

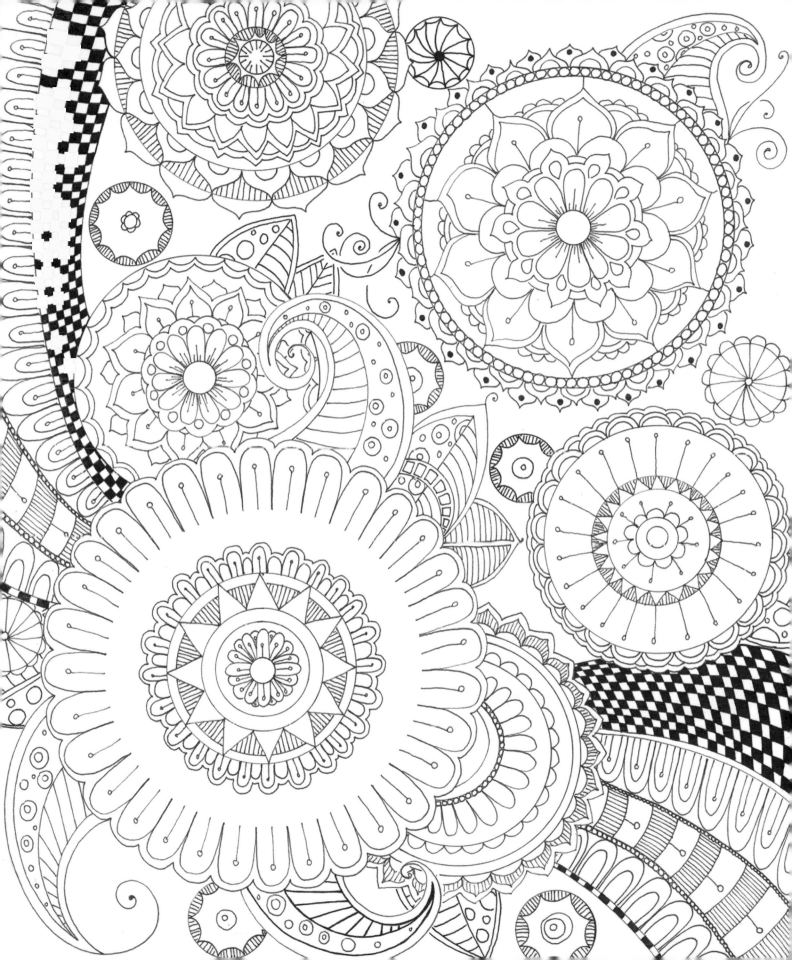

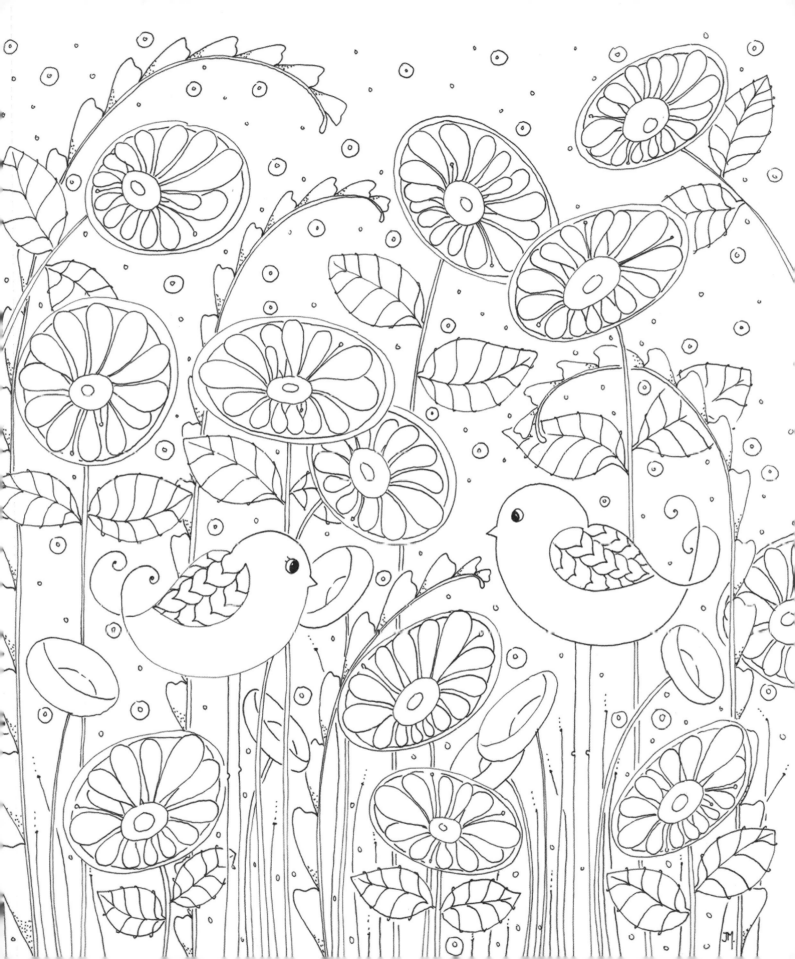

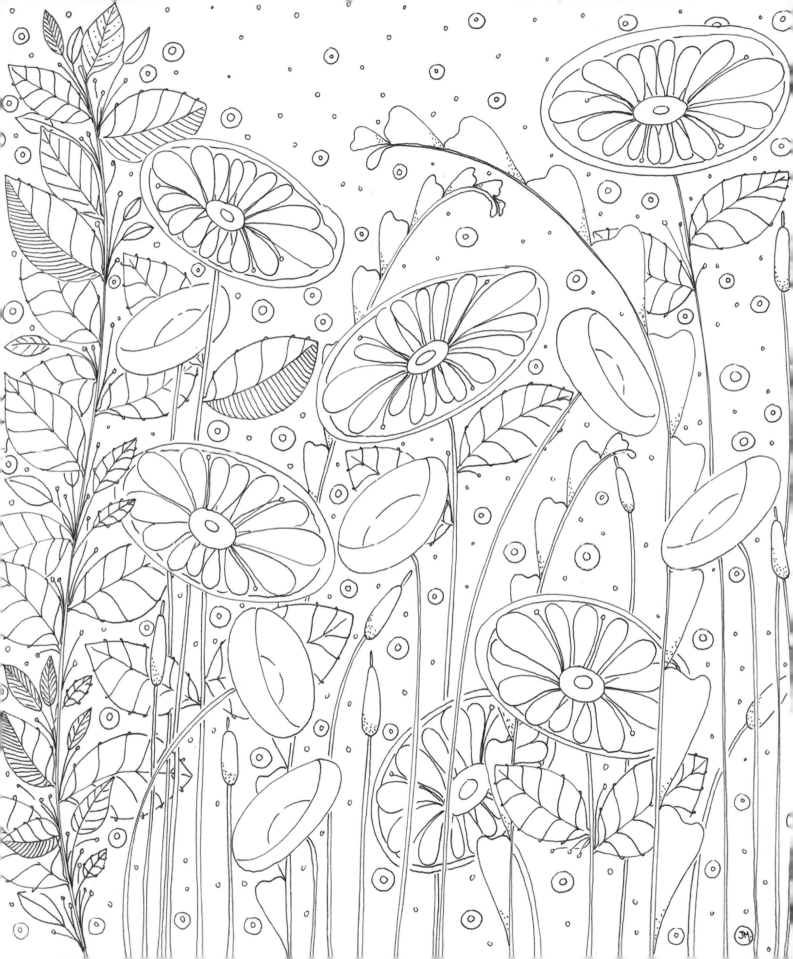

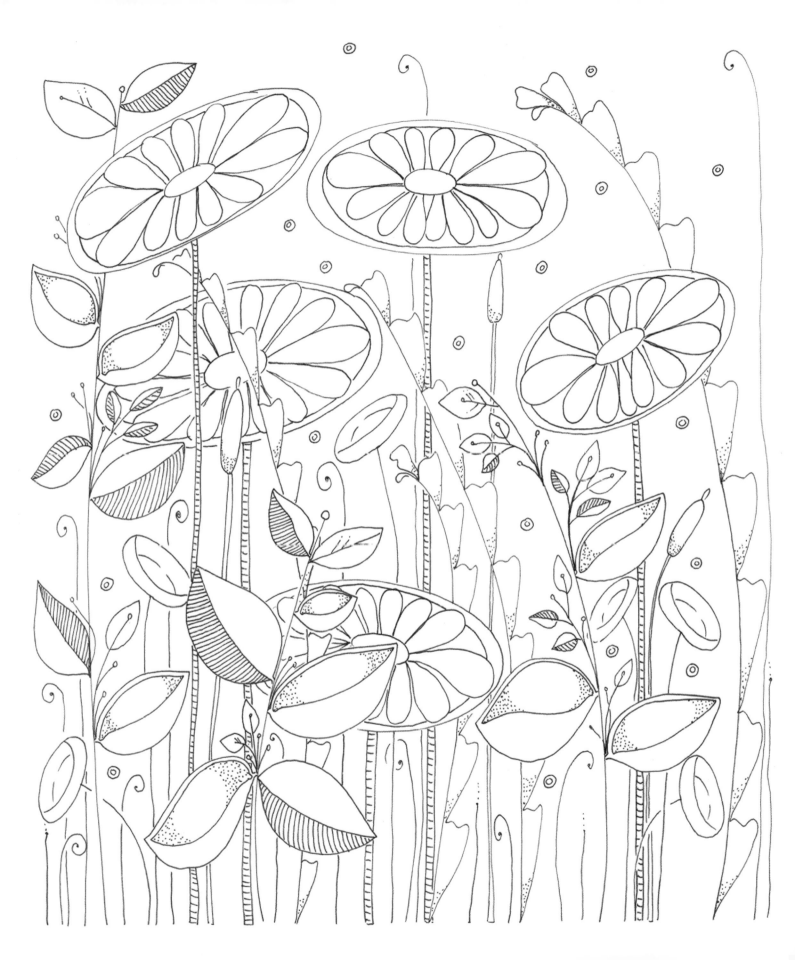

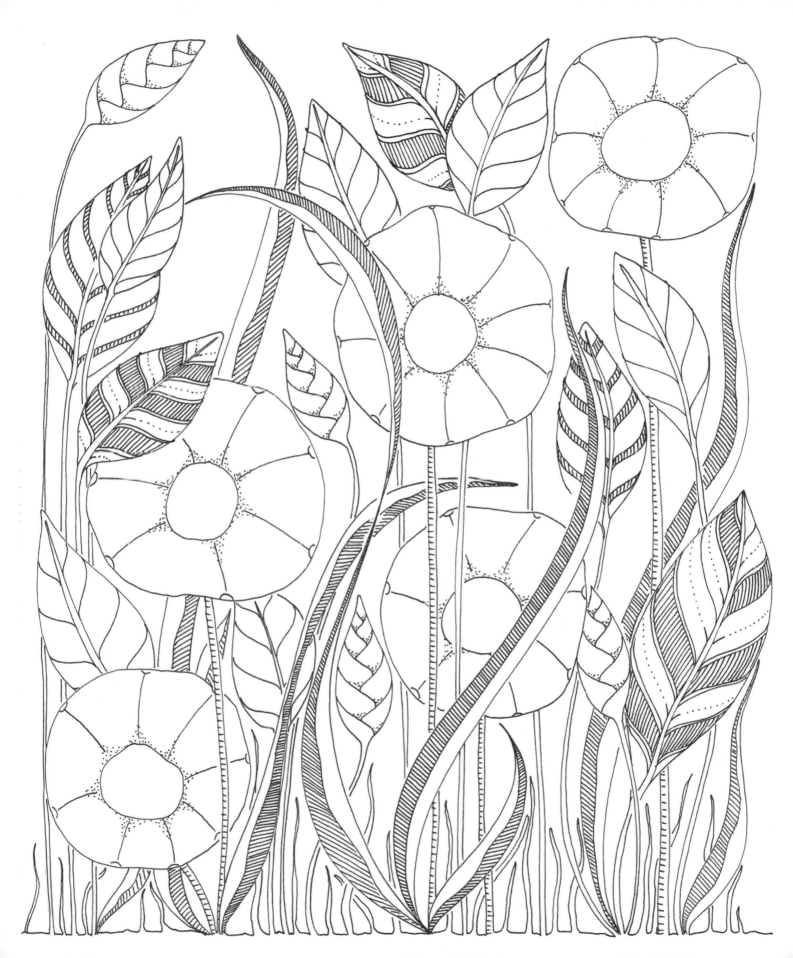

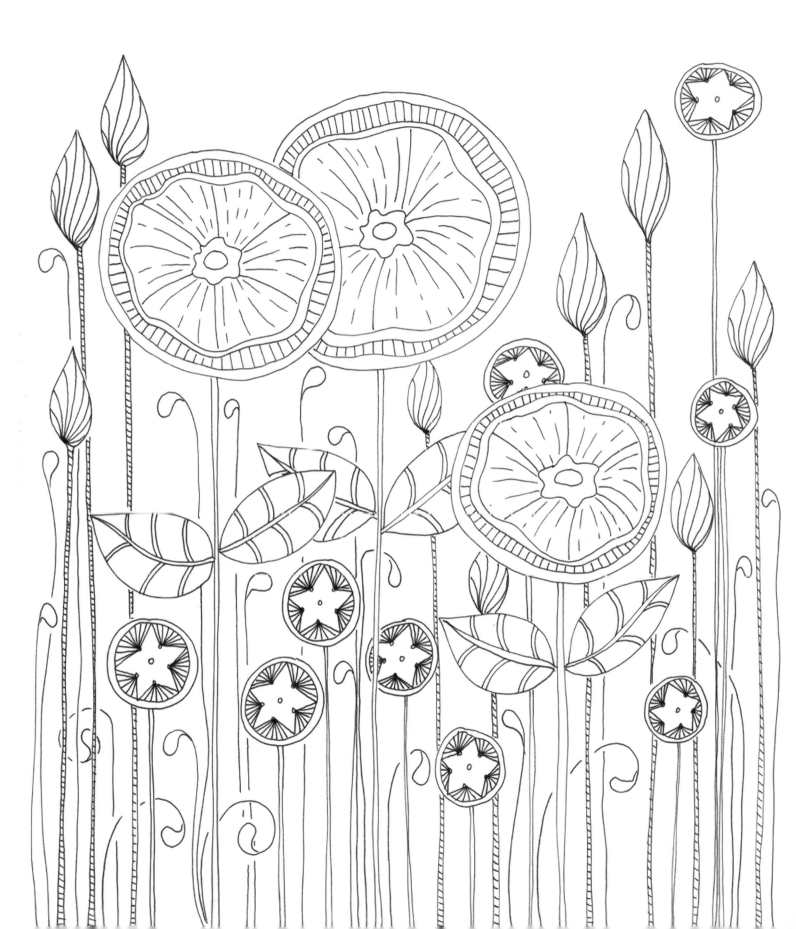

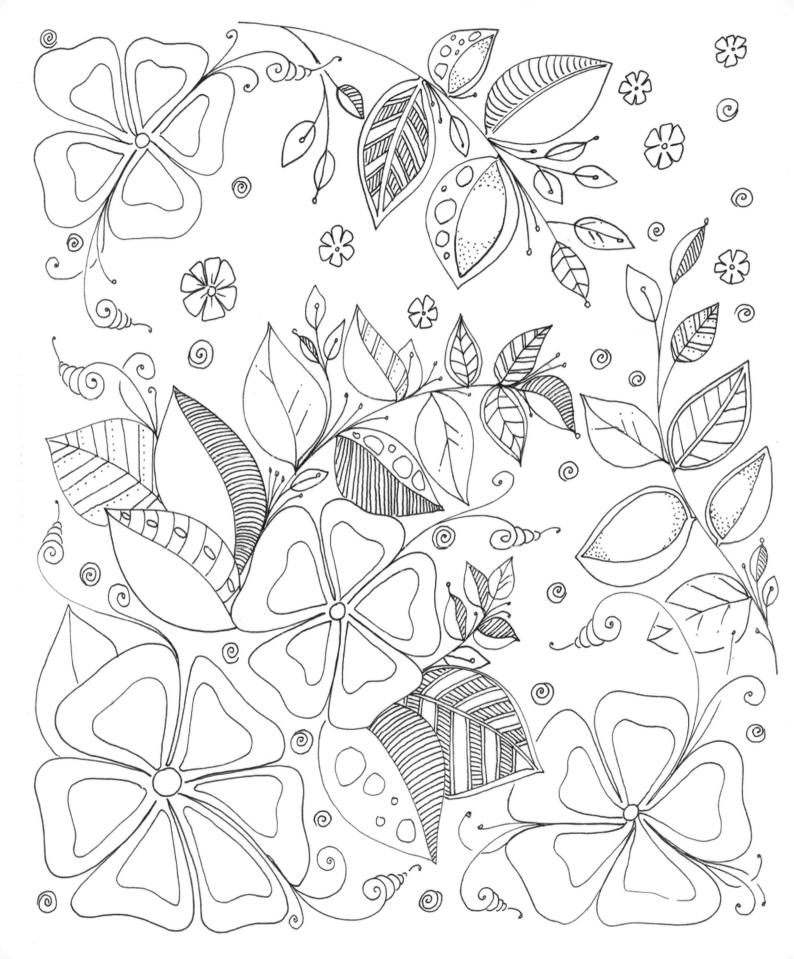

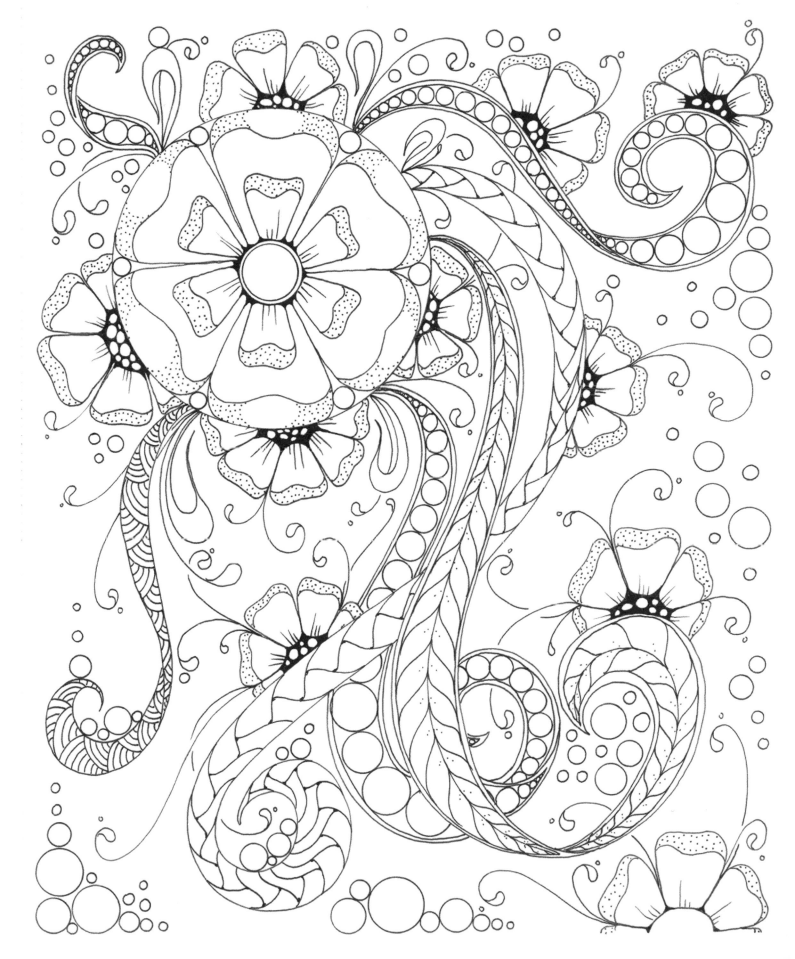

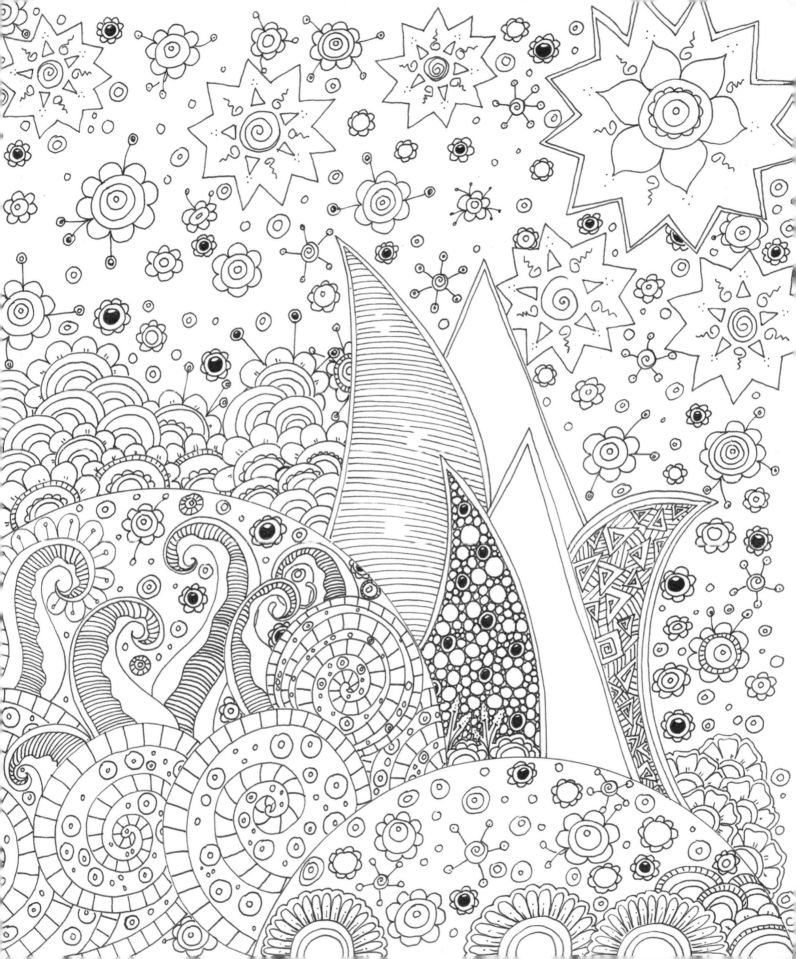

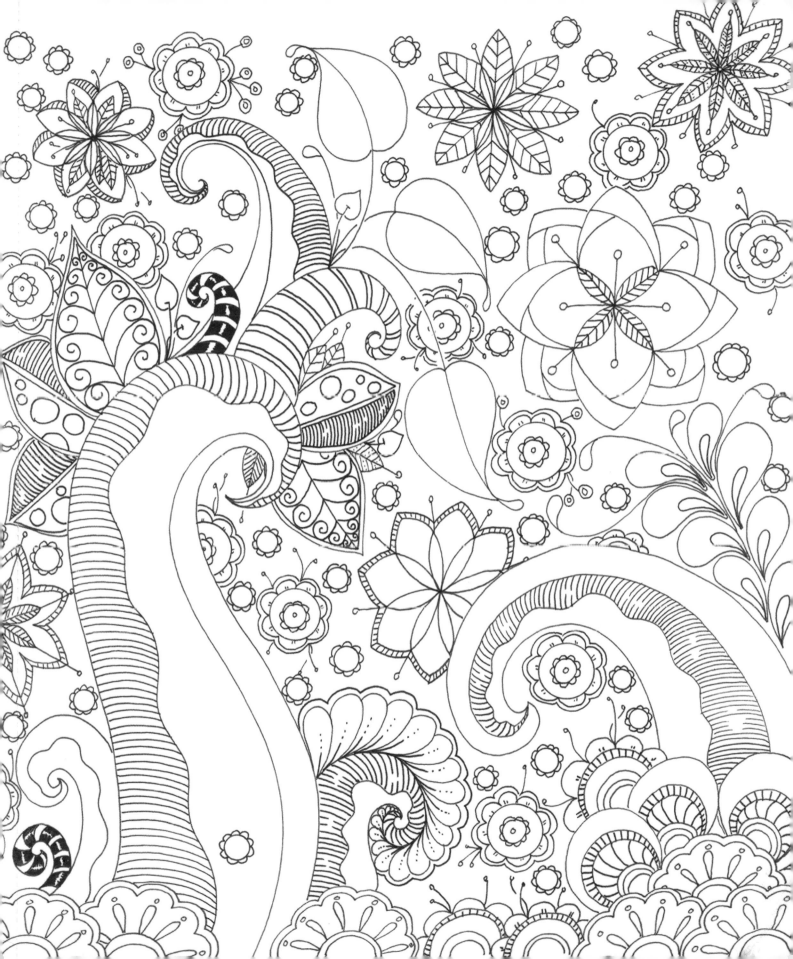

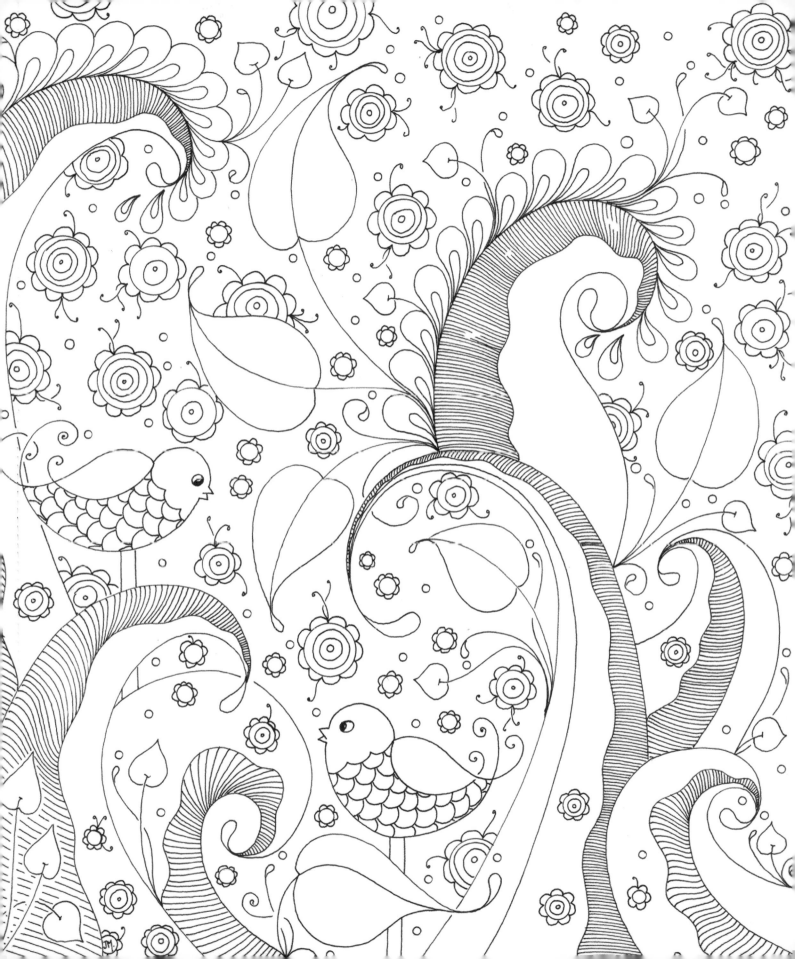

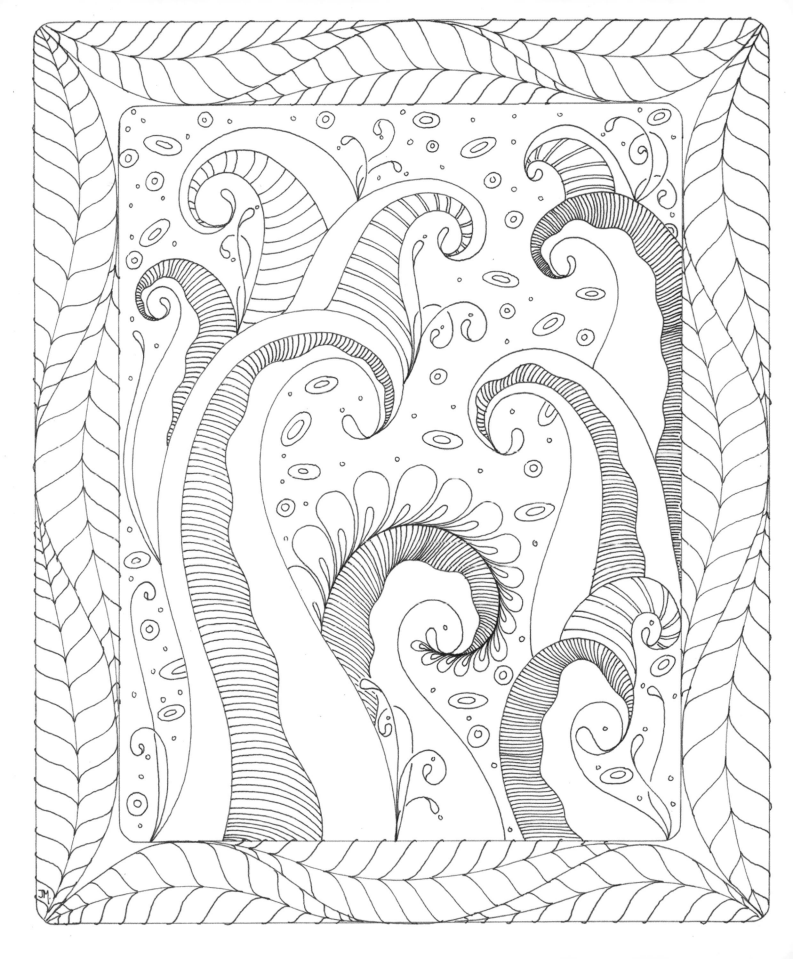

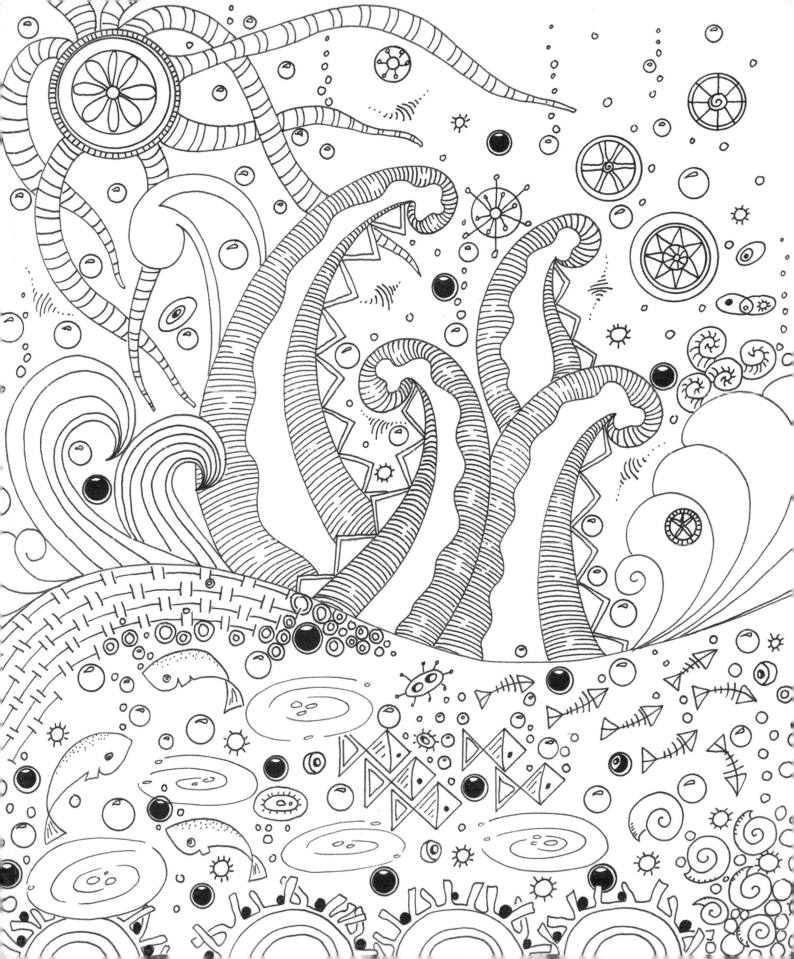

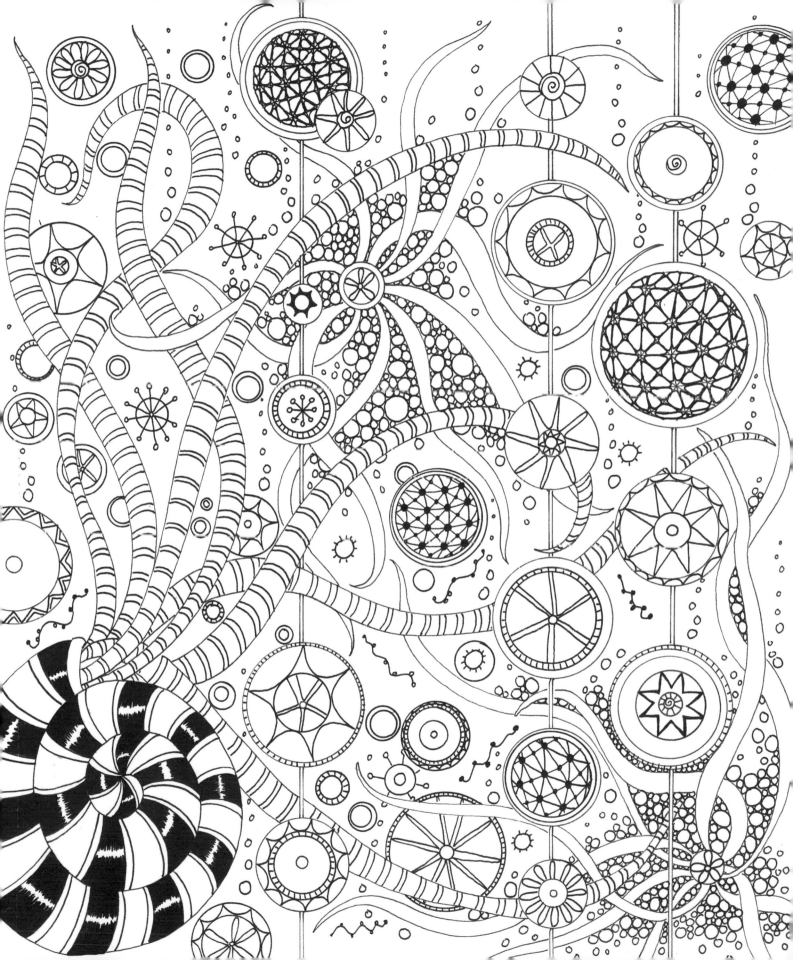

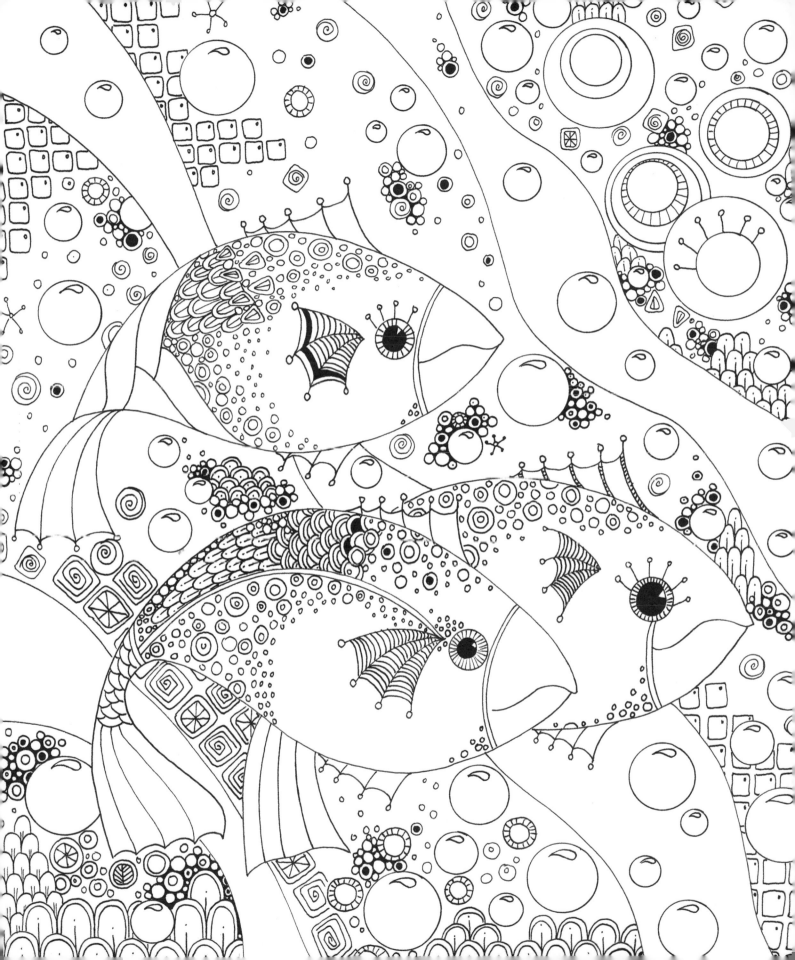

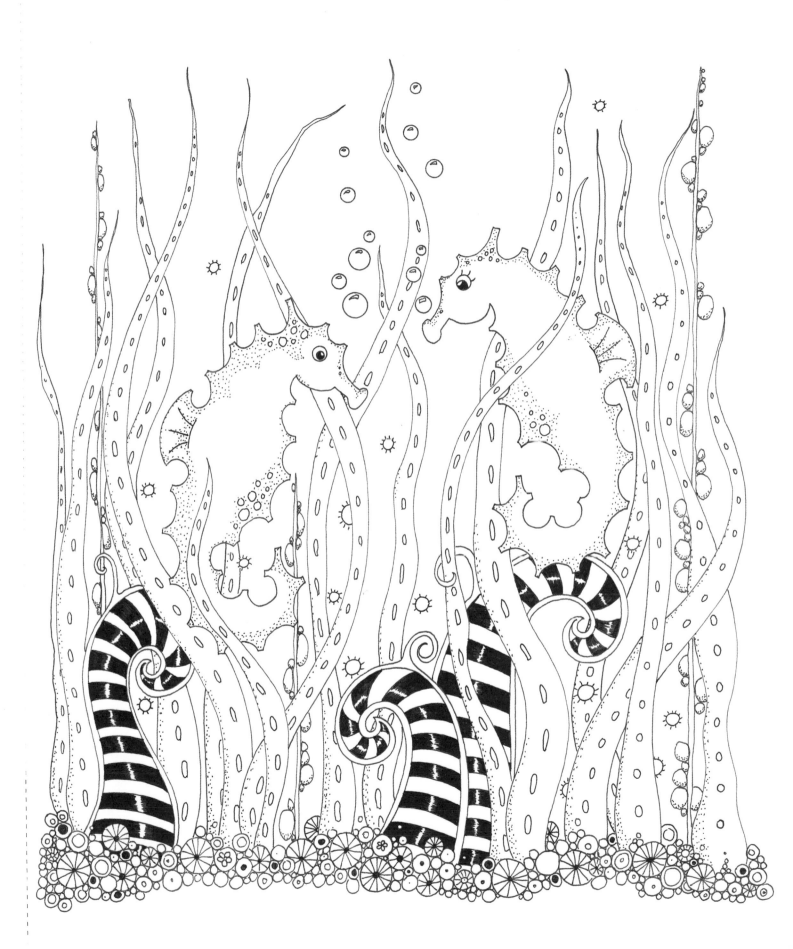

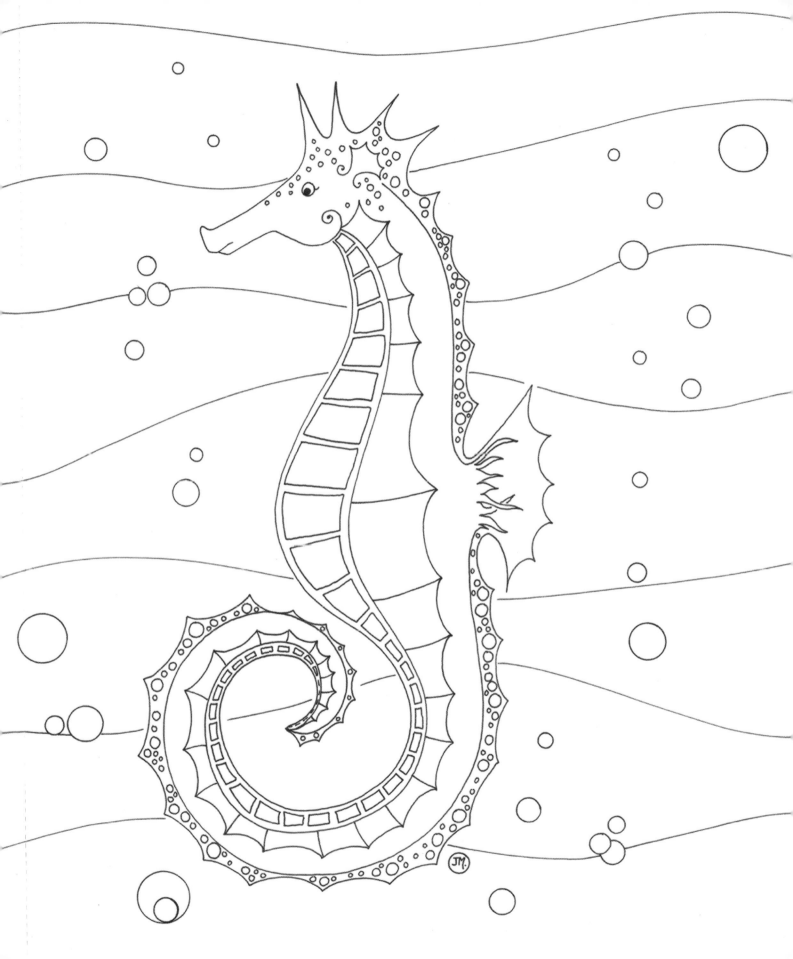

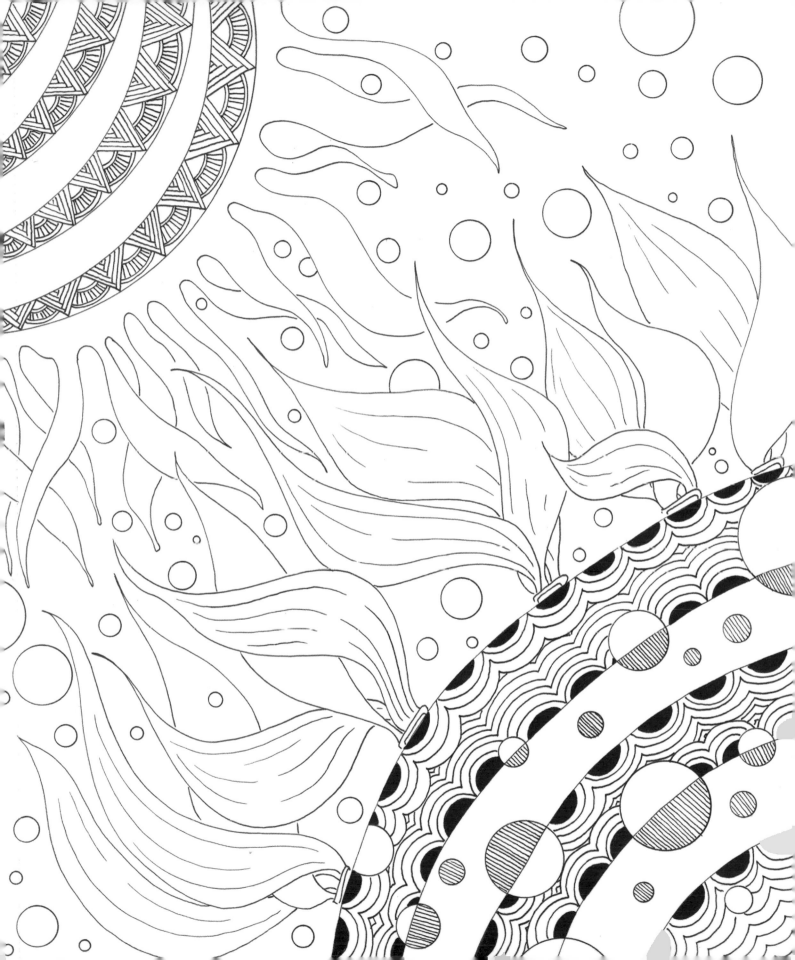

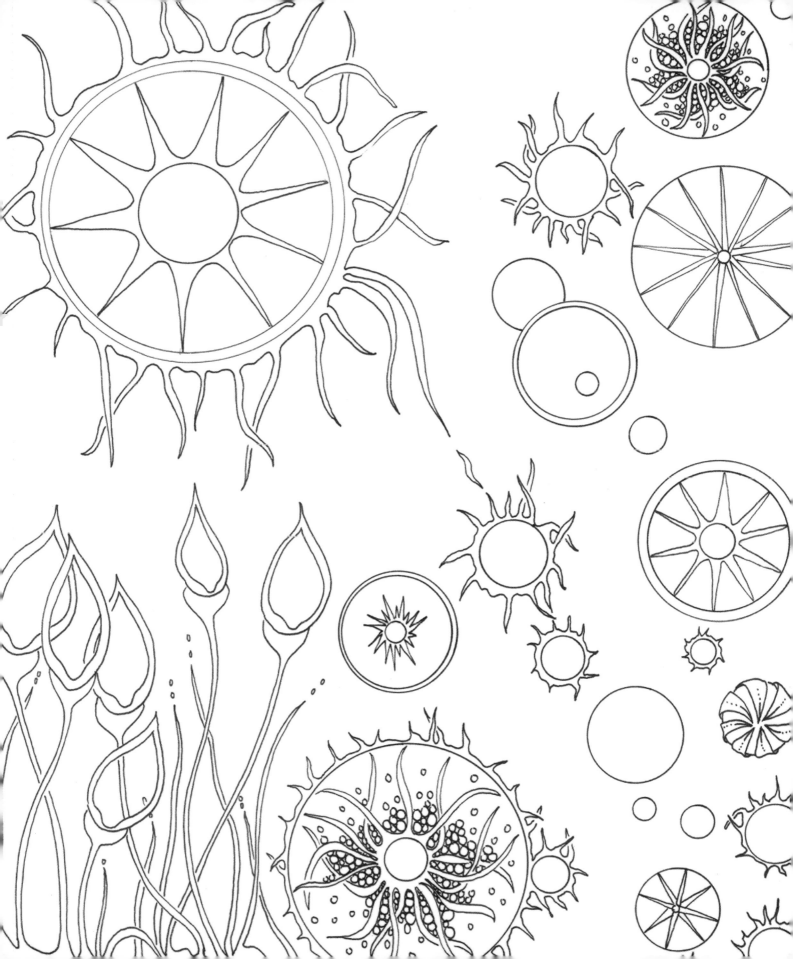

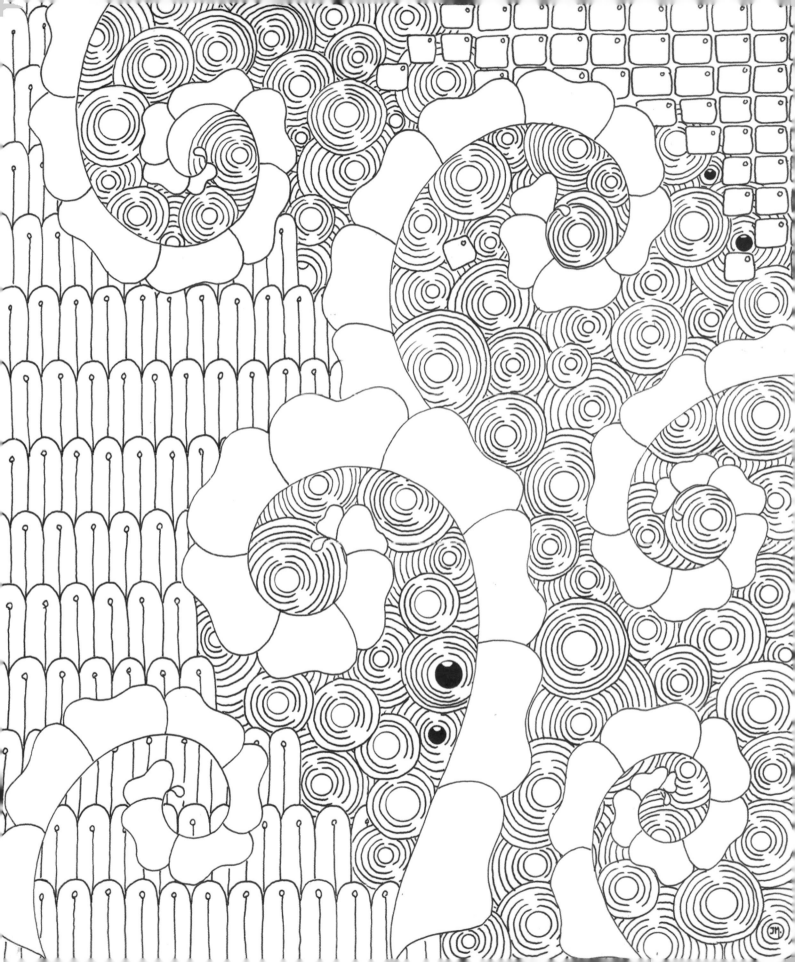

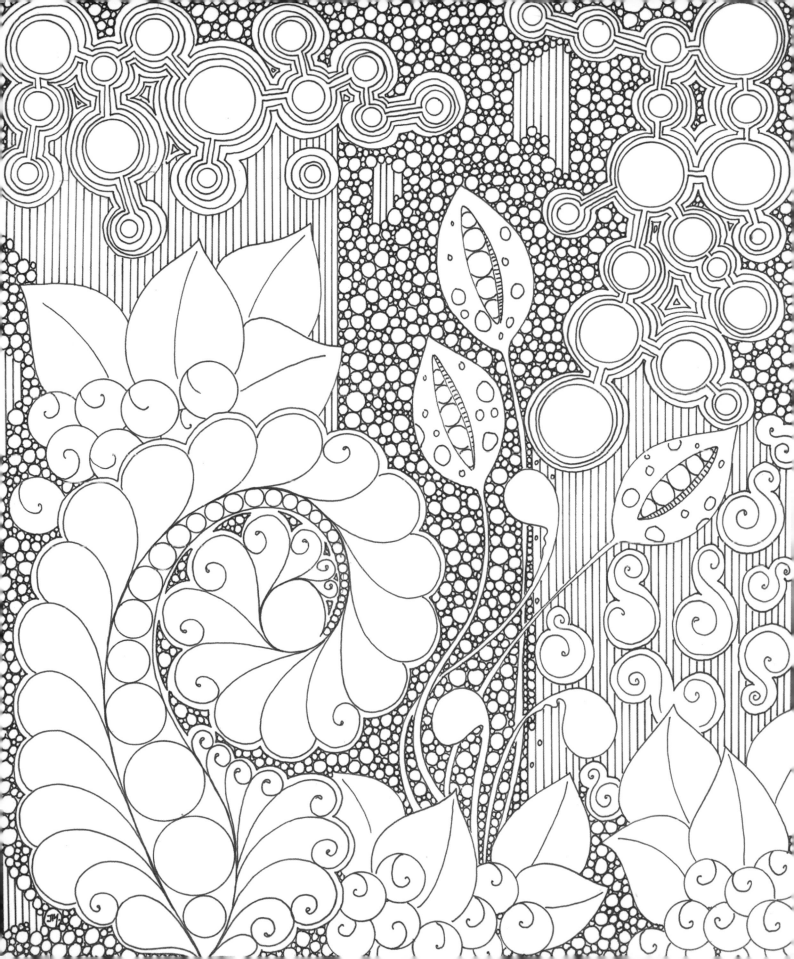

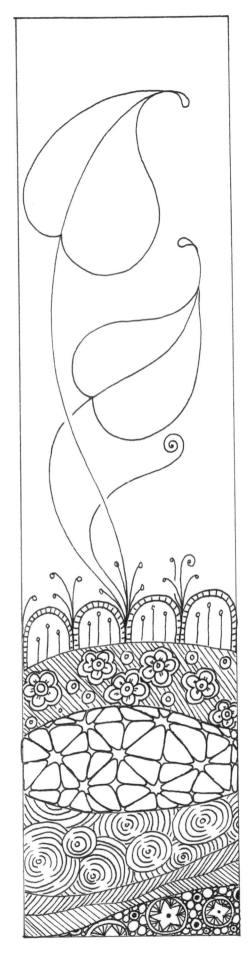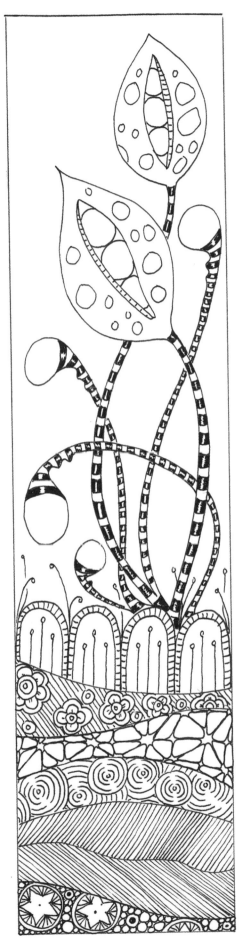

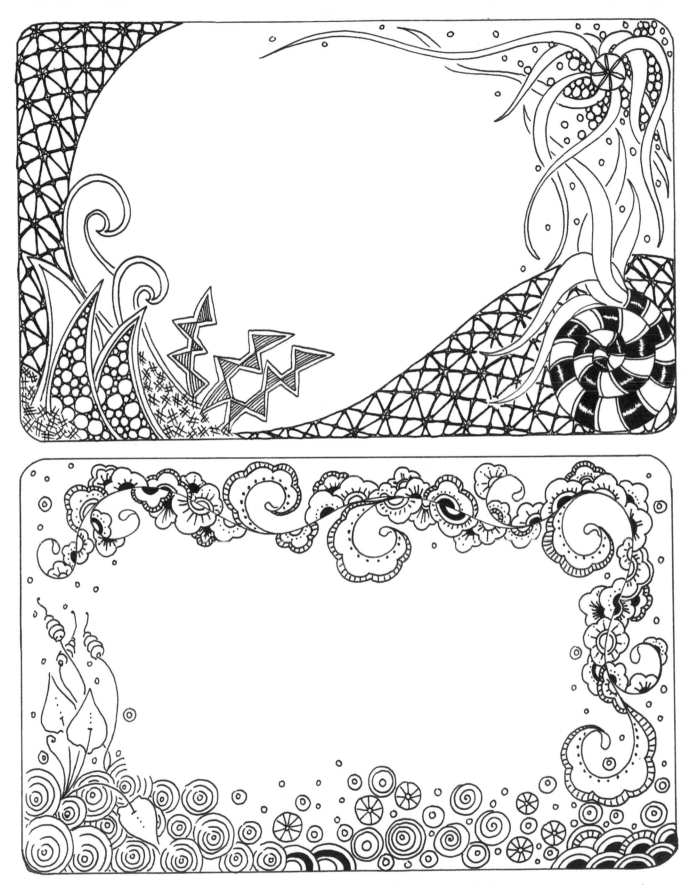

Color these images and use them as book plates or greeting cards, adding your own message in the center space.

TECHNIQUE TRYOUTS

Use these sample pages to practice color-blending techniques and experiment with different mediums and color combinations.

If you are new to coloring it can be useful to try out your own value strip with a graphite pencil, because it will allow you to feel the difference in pressure as you work from light to dark. Start with your pencil barely touching the paper and move it in small circles. In the next circle, add slightly more pressure and continue to add pressure and layers until you achieve a graded light to dark value strip. Different pressures can be achieved by adjusting the position of your fingers as you hold the pencil. For lighter pressure, hold the pencil closer to the end; for heavier pressure, move your fingers closer to the tip as you color the paper.

Now try the same technique with a colored pencil in the value strip circles below.

Here are additional value strips for practicing this technique. Try another color or perhaps a different medium.

In the section on color schemes (page 16), we talked about monochromatic, analogous, complementary, and neutral color schemes. Try out your own combinations on the following two drawings.

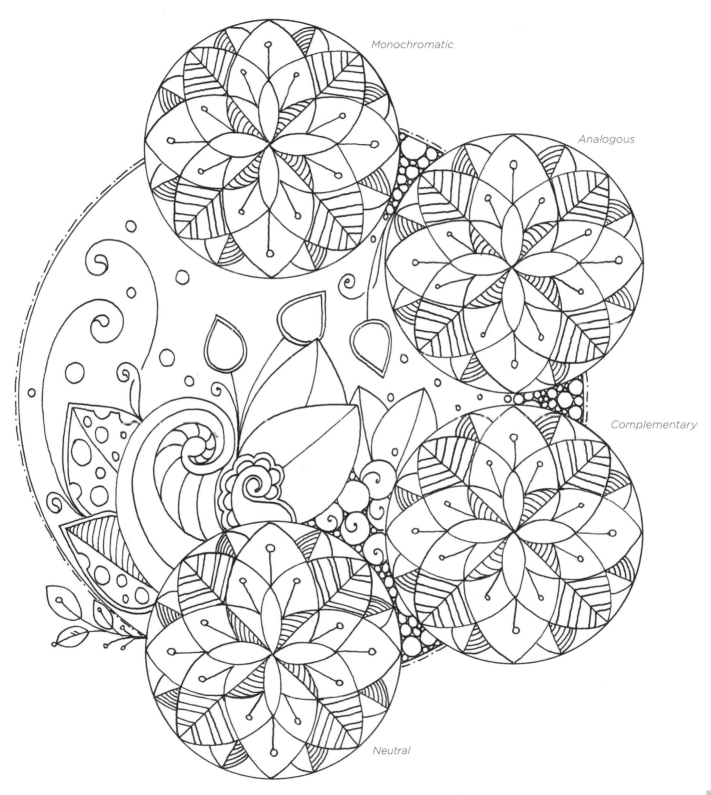

Monochromatic

Analogous

Complementary

Neutral

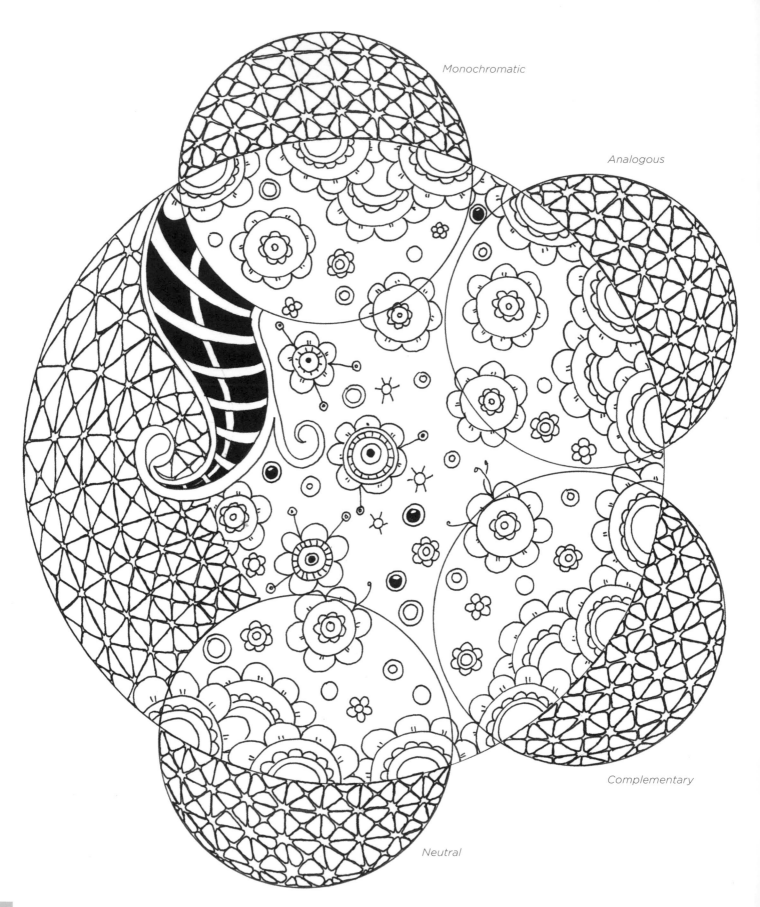

Monochromatic

Analogous

Complementary

Neutral

Referring back to the section on making marks (page 7), make some marks yourself. Start with colored pencils and then try other coloring mediums.

Crosshatching

Stippling

Strokes

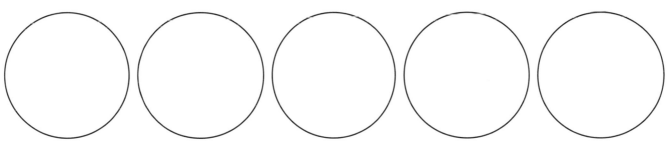

Scrumbling

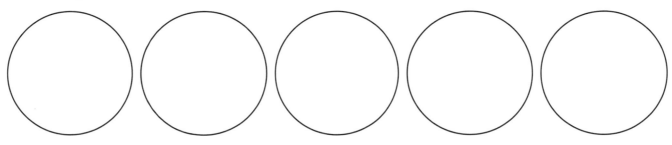

ABOUT THE AUTHOR

Jane Monk lives in Tasmania, Australia, with her husband, James, son, Jonathan, and three cats, Shadow, Merlin, and Jet. She is a self-taught artist who has been drawing since she was a young girl, inspired by the beauty in all things in the natural and man-made worlds. Patterns and repetition—the sometimes quirky and different—are what inspire her work. Drawing is Jane's first love and it is something she is compelled to do every day.

Jane's first book, *Tangle Stitches for Quilters and Fabric Artists*, is the result of combining the art of Zentangle with quilting. Jane is an award-winning machine quilter and quilts professionally for others in her business, Jane Monk Studio. Jane has designed quilt patterns for publication in quilting magazines, including a short DVD showcasing the basics of Zentangle and quilting. She has taught numerous classes in Zentangle, quilting, free-motion stitching, doll making, and drawing. Jane became a Certified Zentangle Teacher in Class #4 in October 2010.

Website: **www.janemonkstudio.com**
Blog: **www.janemonkstudio.blogspot.com**
Email: **jane@janemonkstudio.com**

RESOURCES

The Color Wheel Company
www.colorwheelco.com
Color Wheel

Daler-Rowney
www.daler-rowney.com
Acrylic Artists' Ink

Derwent
www.pencils.co.uk
Studio Pencils
Inktense watersoluble pencils

Faber-Castell
www.fabercastell.com
PITT Artist Pen
Connector Pens (colored markers)
Polychromos Pencils
Albrecht Dürer Watercolor Pencils

Maimeri
www.maimeri.it
Artists' Masking Latex (fluid)

Micador
micador.com.au
Roymac Revolution paintbrushes
Lotus Micador Palette

PanPastel
www.panpastel.com
Artists' pastels in pans

Sakura of America
www.sakuraofamerica.com
Pigma Micron pens
Koi Coloring Brush Pen and Blender Pen
Koi Water Color Field Sketch Travel Kit

Tombow
www.tombow.com/en/
ABT Dual Brush Pen and Blender

Tsukineko
www.tsukineko.com
Fabrico markers

Zentangle
www.zentangle.com
www.zentangle.blogspot.com

Creative Publishing international

First published in the United States of America by
Creative Publishing international, a division of
Quarto Publishing Group USA Inc.
400 First Avenue North
Suite 400
Minneapolis, MN 55401
1-800-328-3895
www.creativepub.com
Visit www.Craftside.net for a behind-the-scenes peek at our crafty world!

ISBN: 978-1-58923-895-4

10 9 8 7 6 5 4 3 2

The Zentangle® art form and method was created by Rick Roberts and Maria Thomas. "Zentangle" is a trademark of Zentangle, Inc. Learn more at www.zentangle.com.

Copy Editor: Kari Cornell
Book Design: Leigh Ring // www.ringartdesign.com
Cover Design: Leigh Ring // www.ringartdesign.com
Page Layout: Leigh Ring // www.ringartdesign.com

Printed in China